Frank M. Hohenberger's Indiana Photographs

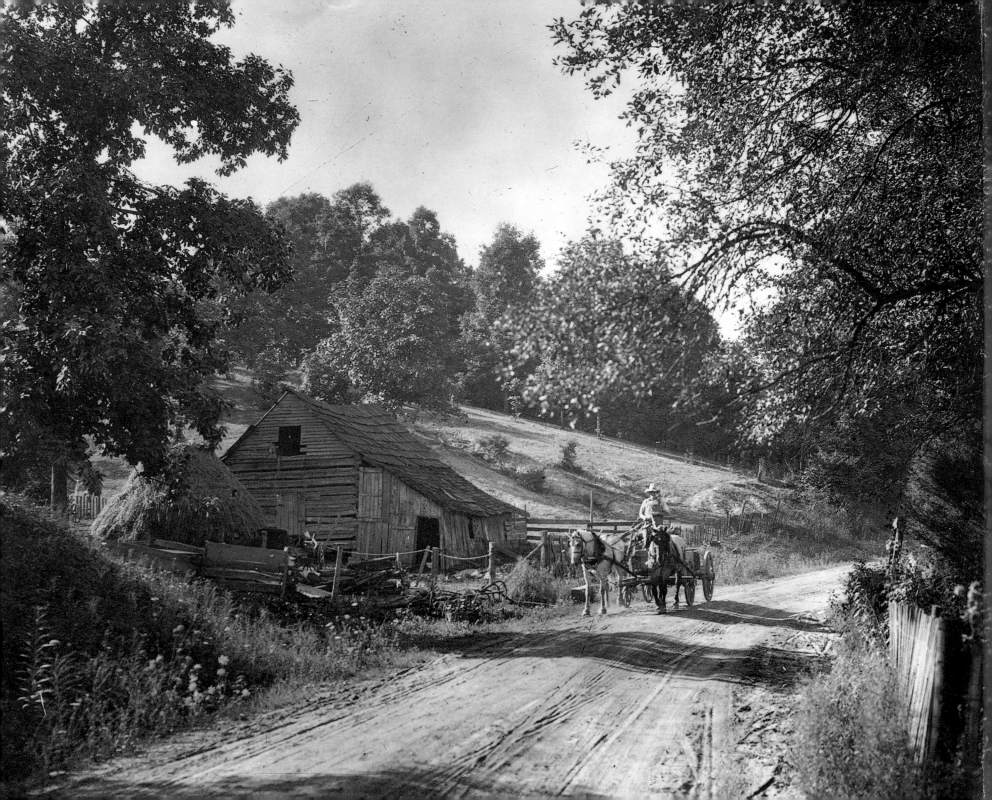

Frank M. Hohenberger's Indiana Photographs

Edited by CECIL K. BYRD

INDIANA UNIVERSITY PRESS *Bloomington & Indianapolis*

Printed in Hong Kong

Library of Congress Cataloging-in-Publication Data

Hohenberger, Frank Michael, date.
 Frank M. Hohenberger's Indiana photographs / edited by
Cecil K. Byrd.
 p. cm.
 ISBN 0-253-31285-X.
 1. Indiana—Pictorial works. I. Byrd, Cecil K. II. Title.
F527.H64 1993
977.2′04′0222—dc20 93-9345

1 2 3 4 5 97 96 95 94 93

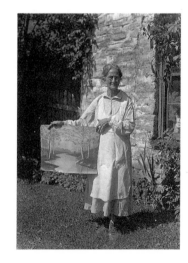

To Esther

Frank M. Hohenberger was a skilled Indiana photographer with a national

reputation for his photographs of the people, their homes, and the scenic environment of Brown County, Indiana, and the county seat, Nashville. From 1917 to 1963, he sold thousands of his prints to individuals, newspapers, and magazines, and was in demand for his lecture on "Historic and Scenic Indiana," which he illustrated with lantern slides from his collection. He also authored a column in the *Sunday Indianapolis Star* under the title "Down in the Hills o' Brown County," for which he was posthumously voted into the Indiana Journalism Hall of Fame in 1976.

Hohenberger was more than a one-county photographer. He traveled far from his Nashville studio in search of subject matter for his camera. He journeyed over the state of Indiana through the years, photographing streets, covered bridges, gristmills, buildings, people, pastoral scenes—anything which he thought was unusual or had historical significance. Beyond Indiana, he photographed in the Carolinas, Virginia, Florida, Cuba, Canada, New England, and the Western states. He was in New Orleans during Mardi Gras, and in Mexico four times recording with his camera. He truly believed the solemn declaration he typed in his diary: "Pictures speak the only language all mankind can understand."

Hohenberger was born January 4, 1876, in Defiance, Ohio. He was christened Frank Michael by his parents, John and Louise Hohenberger. At age five he was orphaned and, along with a sister and two brothers, went to live with his paternal grandparents. Frank was sent to a Lutheran German-language school. When he completed his

schooling, he began working in a print shop owned by his uncle, Michael Kershner, in Paulding, Ohio. There he was taught to set type and to operate a printing press.

No indisputable information has been found concerning Hohenberger's activities between the time he left Paulding, about 1892, and 1902, when he turned up in Indianapolis. He reported in a letter written to a printers' association that he had worked in four states as a printer. When he finished his apprenticeship in his uncle's print shop, he became an itinerant, working for short periods on newspapers in Ohio (probably Dayton), Kentucky (one source points to the *Courier Journal* in Louisville), and Illinois (most probably Chicago).

Hohenberger settled in Indianapolis in 1902, working as a compositor on the *Indianapolis Star*. During that year, he received his membership card in the International Typographic Union. He kept his membership current in the ITU throughout his life and was presented with a sixty-year pin in 1961.

He worked in the composing room of the *Star* until 1909, when he became a photographer for H. Lieber Company of Indianapolis. He was employed by Lieber until 1914, and then was reemployed in the composing room of the *Star*. Because of a change in ownership, he lost his job with the *Star* in 1916. For a few months following, he took a job managing an Indianapolis camera shop. In the summer of 1917, Hohenberger moved to Nashville and established a studio there. Nashville was to remain his professional address until his death in the Fayette Memorial Hospital at Connersville, Indiana, on November 15, 1963.

From a passage in his diary, we know that Hohenberger started photographing in 1902. One of his earliest photos in this publication, "Claypool Hotel," is dated "State Fair Week, 1904." It is assumed that the dated negatives in the collection represent the approximate dates the exposures were taken. Perhaps the 1904 photo represents the earliest negative he thought worthy of preserving.

Hohenberger was the complete photographer. He pressed the bulb, developed the negative, and made his own prints. Throughout his career, he was constantly experimenting, seeking better results. He confided to his diary on July 1, 1918:

> *People think I must be a wonderful photographer. I never show my failures. What a wonderful world this would be for all concerned if we could conceal our failures! No, I make as many and possibly a great deal more errors than other folks, as I am continually at work with photography. When disappointment looms up I just go at it again.*

Hohenberger selected Nashville as the place to open his photographic studio for two reasons. First, he was attracted by the photogenic opportunities offered there. Between 1912 and 1917, he made several trips to explore the

area. His interest was initially aroused when he viewed some Kodak pictures of Brown County taken by an acquaintance. Secondly, he sought stability in his life, which had been marked by frequent changes in employment, and wished to be free from the constraint of a fixed schedule. Nashville meant relative peace, time for reflection, the opportunity to photograph the people and nature in all its aspects, and a chance to develop his own style of photography.

For more than four decades, Hohenberger made a comfortable living selling prints and executing special photographing commissions from his modest studio in Nashville. His income was supplemented by his weekly column in the *Sunday Indianapolis Star*. The column appeared from 1923 to 1932, and from 1936 to 1954 under the title "Down in the Hills o' Brown County." It contained biographical sketches of the residents, stories of gold panning in the county streams, details of court trials, local politics, sketches of local "characters," stories of the early settlers of the county, and news of the local artist colony. Frequently the columns were illustrated with his photos.

His column in the *Star* did much to promote Brown County as a place to live or visit. The tourist boom which exists there today can, in part, be attributed to Hohenberger's homey journalism and creative photography.

In 1952, Hohenberger published a sixty-three-page pamphlet using his *Star* column as the title. It was intended as a brief history of the county, its resources and attractions, and contained some original material as well as reprints from various sources.

He was also the publisher and sole writer for a monthly he named the *Nashville Observer,* issued in twenty-four numbers from February 1955 to February 1957. The monthly was printed on his hand-operated press in his studio. It was, as stated on the masthead, "Devoted to Folks Interested in the Future Welfare of Brown County." The subject matter included politics, business, accommodations for tourists, transportation, and civic improvements. The paper measured only 5¼ by 7¼ inches and consisted of two to three sheets printed on one side only.

The Hohenberger collection now in the Lilly Library at Indiana University, Bloomington, was left as a bequest in his will to the Indiana University Foundation. The Foundation deposited the collection in the Lilly Library in January 1964. In addition to the photographic negatives and prints, the collection contains clippings from various newspapers, a few letters which by accident or design were preserved, and Hohenberger's typewritten diary.

There are more than 17,000 prints and negatives in the collection, not an enormous number for more than sixty years of photography. An unknown number of negatives were destroyed because they did not meet Hohenberger's standard. Many negatives were sold to those who had commissioned the photography. Some of the glass negatives were inadvertently broken. Still, 17,000 permit a comprehension of the range and quality of a long photographic career.

The clippings in the collection are mostly from Nashville and Indianapolis newspapers. Occasionally, items

from an out-of-state paper or from a Bloomington or Columbus paper were preserved. The clippings reflect Hohenberger's interest in artists, bridges, water mills, canals, and the obituaries of well-known Hoosiers, some of whom he had photographed. His columns "Down in the Hills o' Brown County" from the *Sunday Star* are represented. Some of his photos taken in Cuba and Mexico which were published in the rotogravure section of the *Sunday Star,* as well as occasional topical contributions to the *Indianapolis News,* were clipped and preserved.

The manuscripts in the collection are a miscellany. There are a few letters received, which Hohenberger thought important enough to retain, invoices, a typed account of his trip to Cuba, a few carbon copies of letters sent, carbons of some of his Sunday columns for the *Star,* lists and addresses of people to whom he sent his brochures of prints for sale, an account book, and, most important, his diary.

The letters are mostly acknowledgments and words of praise for photos received by the correspondents. There is, however, a series of letters from Webb Waldron, a journalist who was writing an article on Hohenberger which was published in the *American Magazine* in October 1933. The other significant series of letters were from Gene Stratton-Porter, her husband C. D. Porter, and her secretary. They relate to photography which Hohenberger did at their log cabin home on Sylvan Lake near Rome City, Indiana.

The account book demonstrates the meticulous way Hohenberger conducted his business. He recorded in his "Cash Book" the names of his customers, the items sold, and the amount received for the years 1956–62. In addition, he recorded postage paid, and car and sundry expenses for some years. His income was modest, but a bank card inserted in the account book listed a balance on June 23, 1963, of $3,701.79 in his checking account and $10,135.60 in a savings account. (Hohenberger spent much of his income on photographic supplies, equipment, and journals of the trade.)

The Hohenberger diary consists of 573 pages, typed single-spaced on loose-leaf, legal-size paper. The first entry was dated October 1, 1917, and the last April 21, 1957. It contains much about Brown County people, their manners and customs, their pithy talk in the vernacular, and reports on his friends in the artist colony. Many of the anecdotes were recorded in his Sunday column in the *Star*. In addition to the personalities he wrote about, he recorded his experiences on some of his photographic trips both in and out of the county.

The diary also contains notes for his lectures on nature, long passages from photographic journals, and records of expenses on out-of-town trips. He did not make daily entries in the diary, nor did he reveal much of himself. Frequently a sentence or paragraph can be interpreted as a nudge to his memory in writing his *Star* column. In reading the diary today, one has the impression that the dialect of the local people was exaggerated and the anecdotes were improved by Hohenberger's imagination.

There have been two previous publications relating to Hohenberger which contain reproductions of his photos. The first, by Lorna Lutes Sylvester, appeared in three installments in the *Indiana Magazine of History* (September 1975, March and September 1976), under the title "Down in the Hills o' Brown County: Photographs by Frank M. Hohenberger." Sylvester's articles, the most comprehensive of the two publications, contained reproductions of 127 Hohenberger photos. All but two of these were of Brown County residents and scenes.

The second publication, a book by Dillon Bustin titled *If You Don't Outdie Me: The Legacy of Brown County,* was published by Indiana University Press in 1982. Bustin used seventy-three Hohenberger photos in his book, all of people and scenes of Brown County. Both Bustin and Sylvester quoted liberally from Hohenberger's diary in their publications.

This publication contains 124 reproductions of Hohenberger's photographs, taken throughout the state of Indiana between 1904 and 1950. There are photographs of scenes in Indianapolis, Madison, Vevay, Nashville, Corydon, Saint Meinrad, Lincoln City, Santa Claus, Metamora, Brookville, Bloomington, Ellettsville, Martinsville, Avoca, Spencer, West Baden Springs, Liberty, Connersville, Spring Mill State Park, New Harmony, Aurora, Birdseye, Logansport, and Rome City. The photos represent subjects Hohenberger was fond of recording with his camera: people, nature scenes, street scenes, log cabins, covered bridges, ferries, gristmills, railroad stations, trains, and buildings he thought picturesque or historically significant. Some of the photos demonstrate the gradual transition in transportation from horse to automobile. A number of the buildings photographed have been razed. Some have been allowed to deteriorate, while others have been altered to meet current requirements. Many of the landscapes have been radically altered by the passing of years.

Much assistance in compiling this volume was received from staff members of the Lilly Library at Indiana University, Bloomington: Cheryl Baumgart, Rebecca Cape, Martha Etter, Lisa Killion, Heather Munro, and Saundra Taylor. Dorothy B. Bailey, archivist of the Brown County Historical Society, made many useful suggestions. Fred and Malinda King of Nashville, who were close friends of Hohenberger, shared their recollections of him and their knowledge of Brown County geography and people on numerous occasions. As customary, Esther S. Byrd edited and typed the preliminary manuscript.

Cecil K. Byrd
Bloomington, Indiana

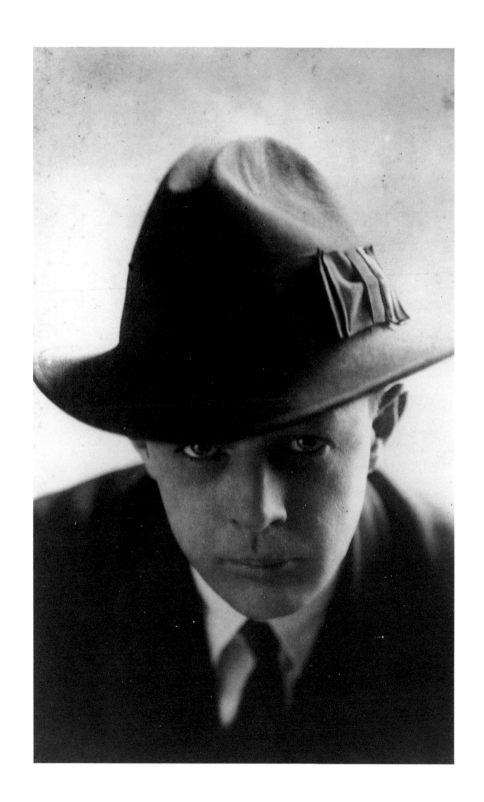

Hohenberger as a young man.

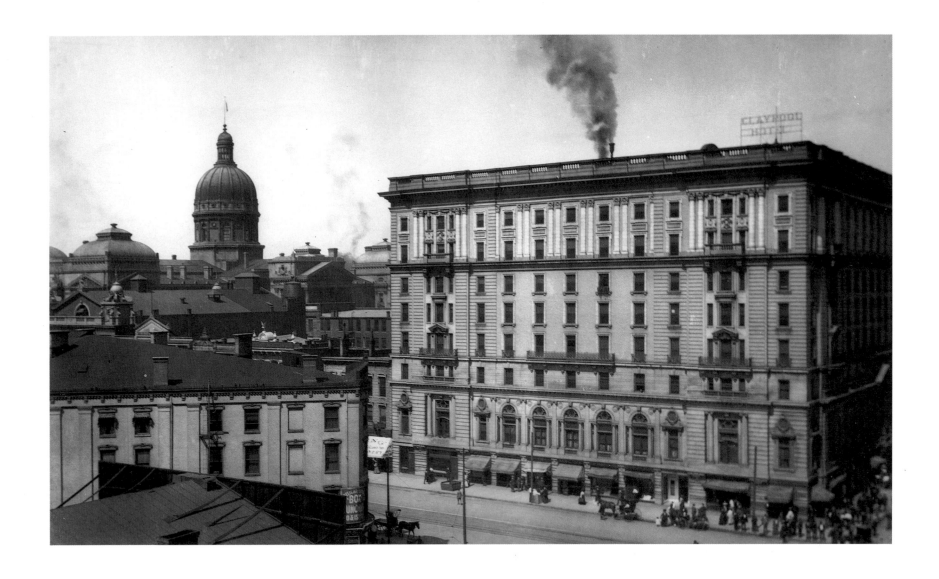

The Claypool Hotel, located in Indianapolis on the northwest corner of Illinois and Washington streets, photographed in September 1904. Constructed on the site of the Bates House, the Claypool was completed in 1902 and was one of the city's finest hotels. It consisted of eight stories with a roof garden and all the amenities to attract both the young and romantic and fraternal and political organizations. The hotel was ravaged by fire in the 1960s and demolished. Claypool Court now occupies the site.

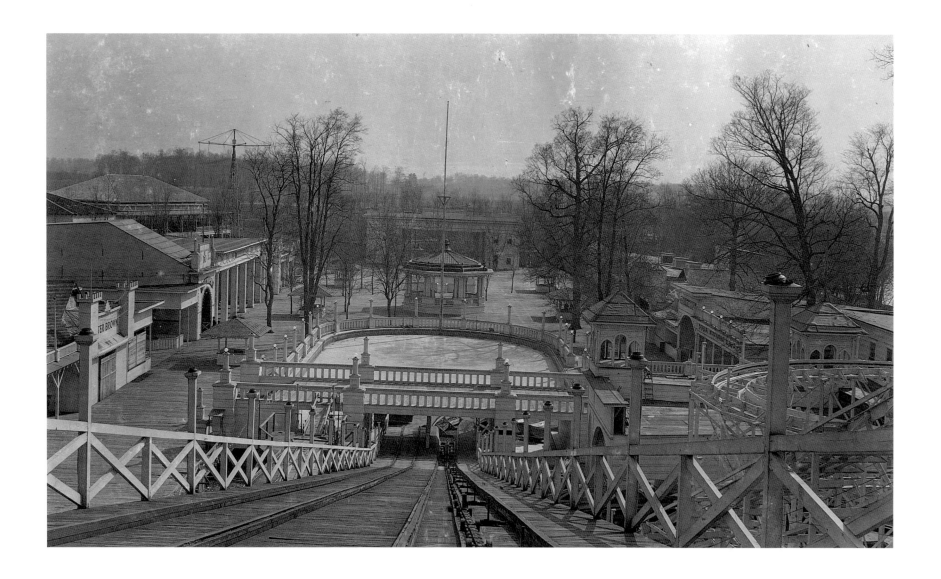

White City Park, Broad Ripple, as photographed in April 1907. Broad Ripple was once an incorporated town which was annexed to the city of Indianapolis in 1922.

White City Park was constructed by an amusement company in 1904. It had picnic grounds, a variety of concessions, rides, amusements, and even steamboat rides on the White River. The amusement park was destroyed by fire in 1908 but was rebuilt by the Union Traction Company, which had acquired the land and property. The city of Indianapolis purchased approximately sixty acres of the land in 1945 and named it Broad Ripple Park.

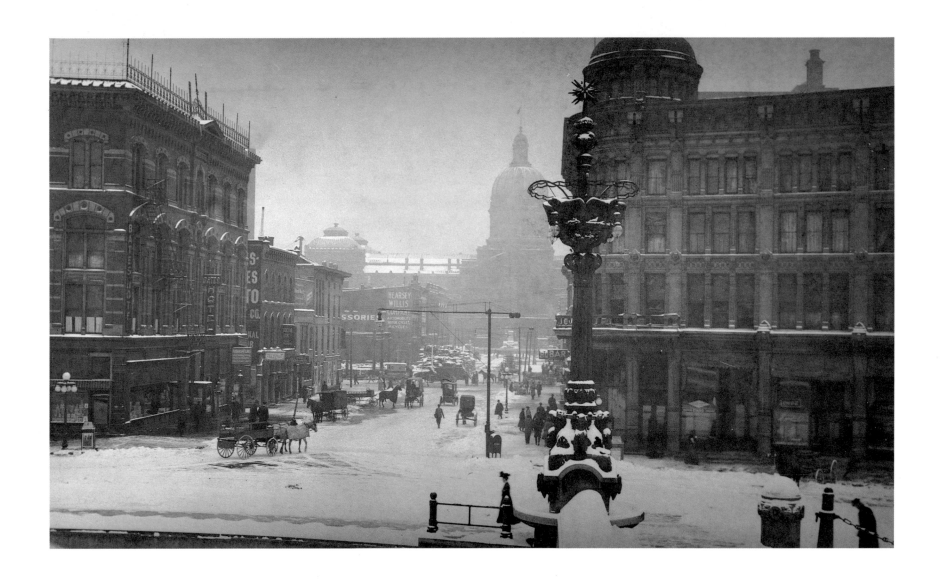

View from Monument Circle in Indianapolis, looking west
on Market Street toward the shrouded State House. Taken
on January 7, 1911, following a heavy snow. To the right is
a section of the English Hotel.

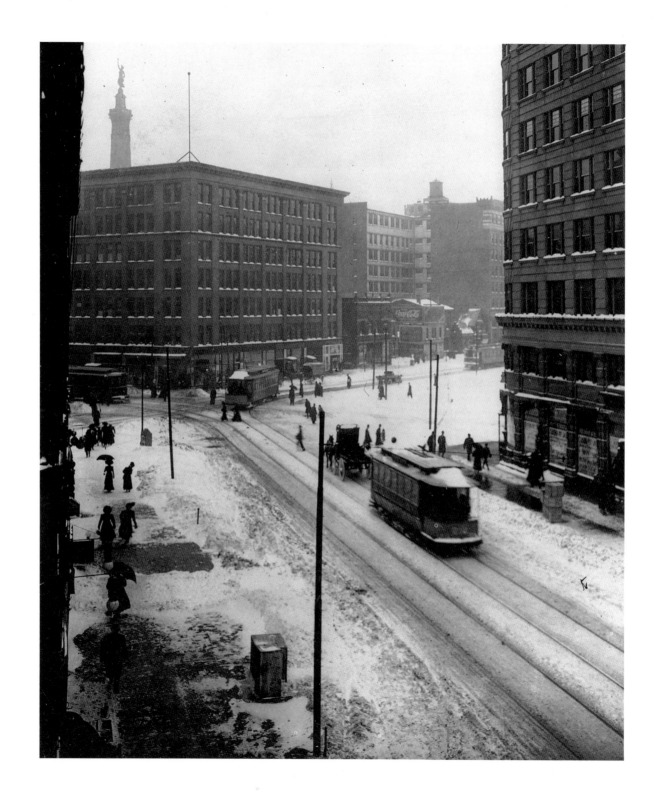

Winter scene on Massachusetts
Avenue, Indianapolis, undated.

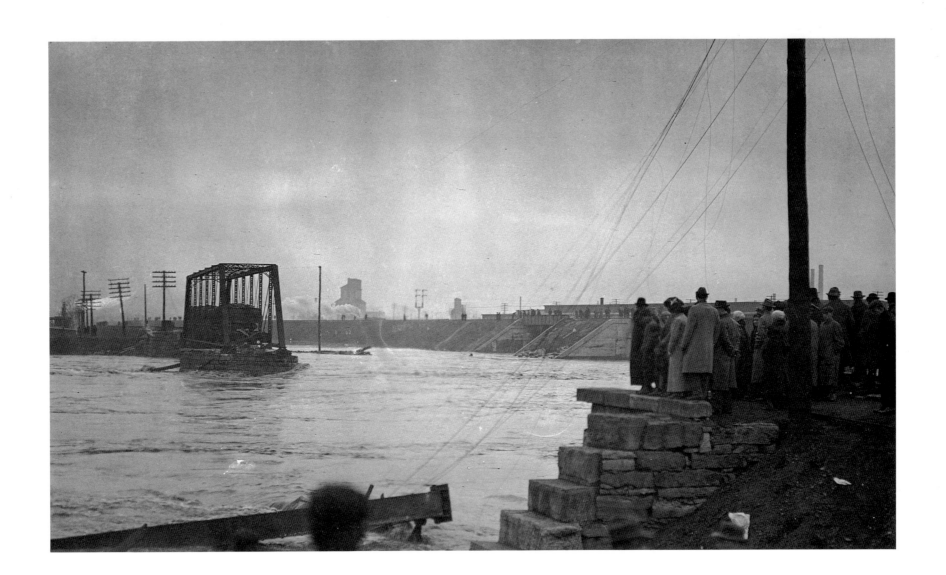

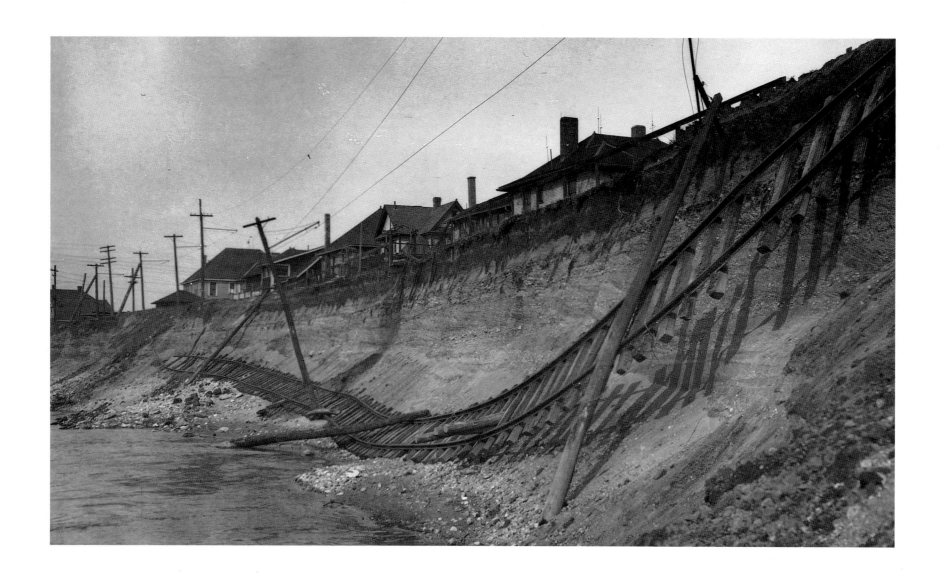

The mighty floods of March 1913 brought death and destruction to Indianapolis and most cities in the Midwest situated along rivers. On March 25, the White River levee gave way at Morris Street, and the swollen waters swept through the west side of Indianapolis.

These two photos show the destruction of the Washington Street bridge over the White River, and the tracks of the Union Traction Company undermined by the waters of Fall Creek, below Thirtieth Street.

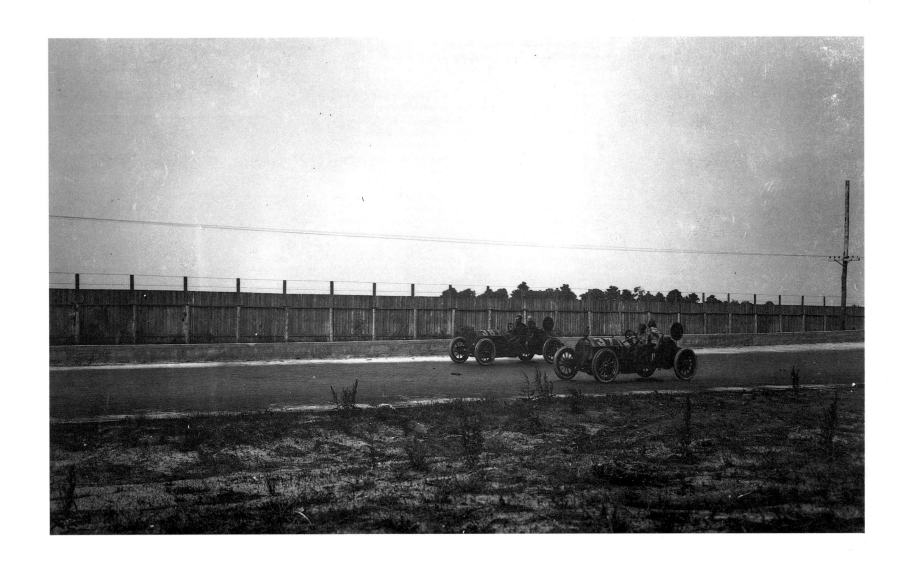

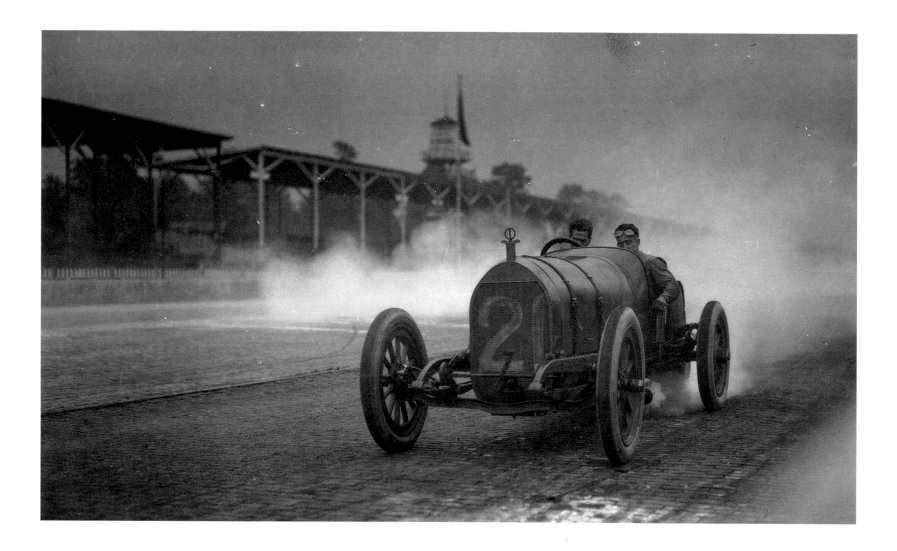

These two photos were taken on May 8, 1911. They show some of the forty race cars which qualified for the first 500-mile Memorial Day race at the Indianapolis Motor Speedway, held on May 30, 1911.

The Indianapolis 500 is America's greatest automobile-racing classic, attracting the largest crowd of any sports event in the world. This first Indy 500 drew an estimated 80,000 spectators and race cars from foreign and domestic makers such as Mercedes, Simplex, National, Stutz, Benz, Fiat, and Buick.

The race was won by Ray Harroun in six hours, forty-two minutes, at an average speed of 75.59 miles per hour. He drove a black and yellow Marmon Wasp, a car manufactured in Indianapolis. He was able to drive without a mechanic at his side because he had rigged the industry's first rearview mirror in his racer, eliminating the need for a second rider for rearward viewing. As can be noted from these photos, the other cars had both driver and mechanic on board.

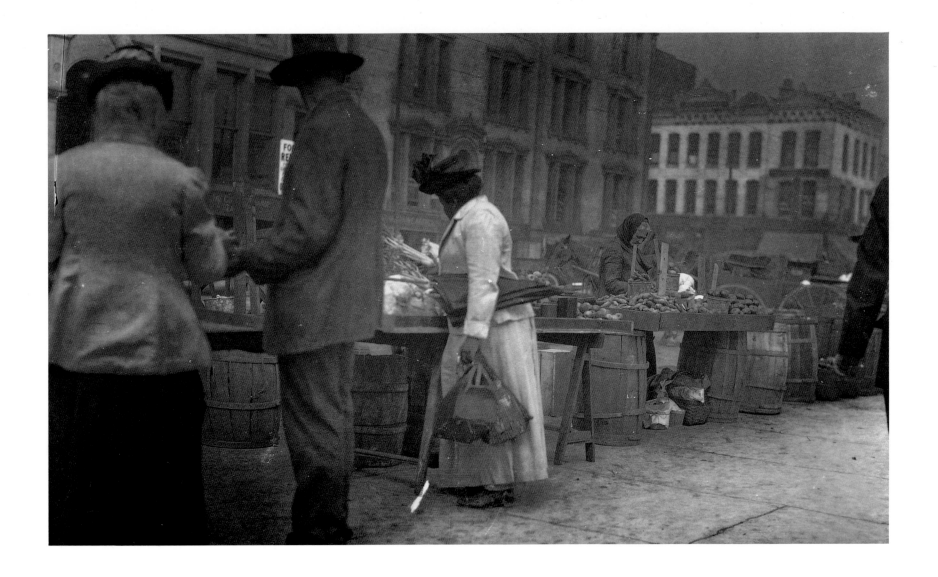

A cloudy day at the market, about 1915. A site for a city market was in the original design for Indianapolis. The market was established at its present location on East Market Street in 1832. A new market was constructed in 1886 next to Tomlinson Hall, built the same year. Both buildings served as a covered market place. The ground floor of Tomlinson (the building served as a civic auditorium) housed an extensive fresh vegetable market. The city market adjoined it on the east. The outside sidewalk offered convenient space for many of the vendors. As it exists today, the market dates from 1977.

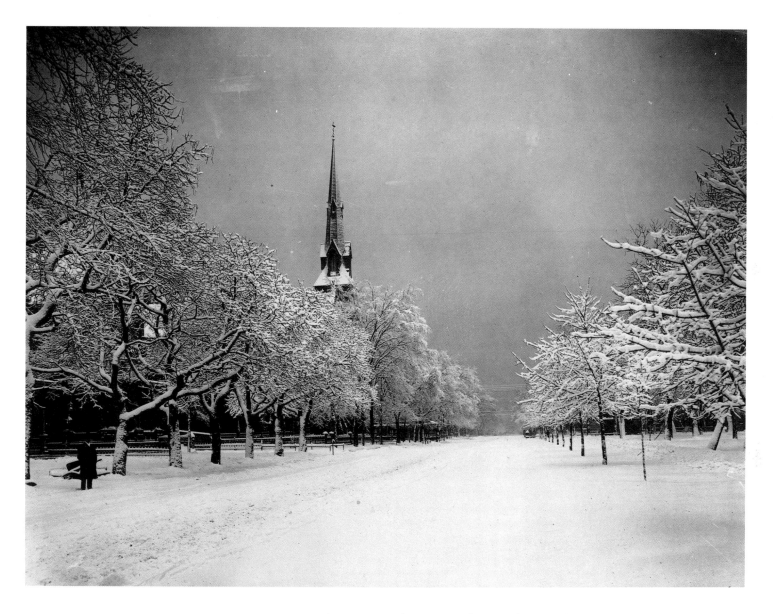

A snow scene taken in 1930, featuring the spire of the Second Presbyterian Church at the corner of Vermont and Pennsylvania streets in Indianapolis. This building served the congregation from 1870 until 1959, when it was razed to permit completion of the World War Memorial Plaza.

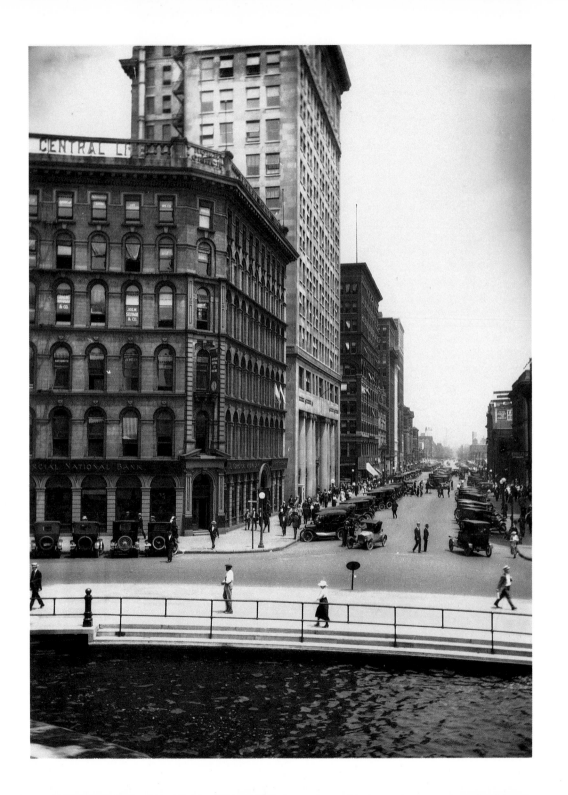

Market Street in Indianapolis, looking east from the Circle in the 1920s. Hohenberger named this print "Bankers Row." The second building in the photo is now Bank One.

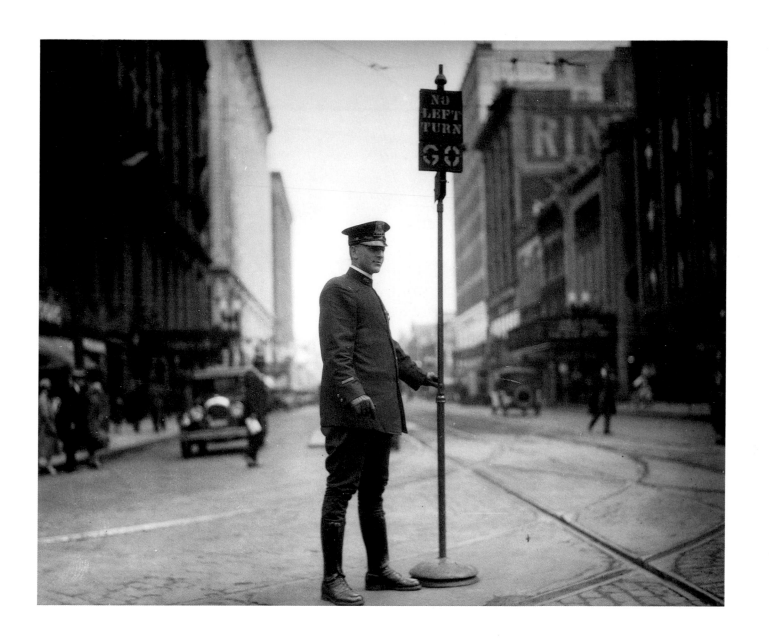

An Indianapolis policeman directs traffic at the
corner of Washington and Illinois streets in
April 1926.

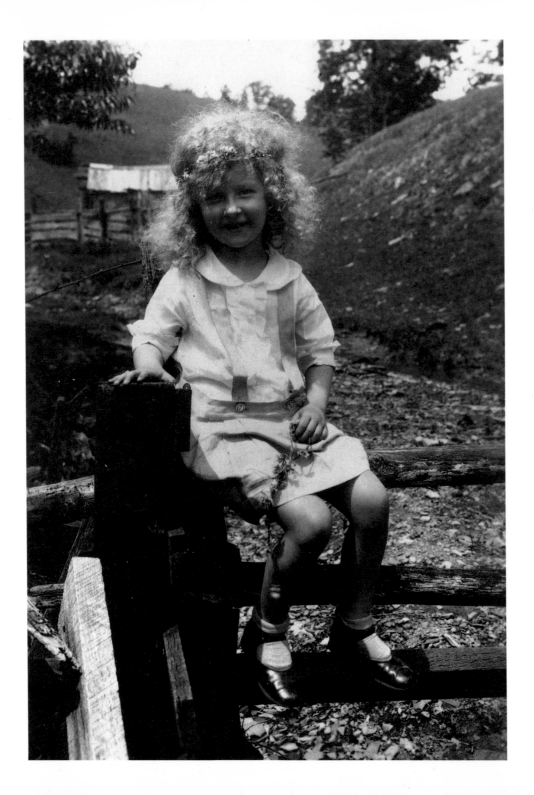

The daughter of Mr. and Mrs. Herbert Bloemker of Indianapolis, Jeanne Anne, wearing a chaplet made from nature, photographed atop a rail fence in Brown County. Date unknown.

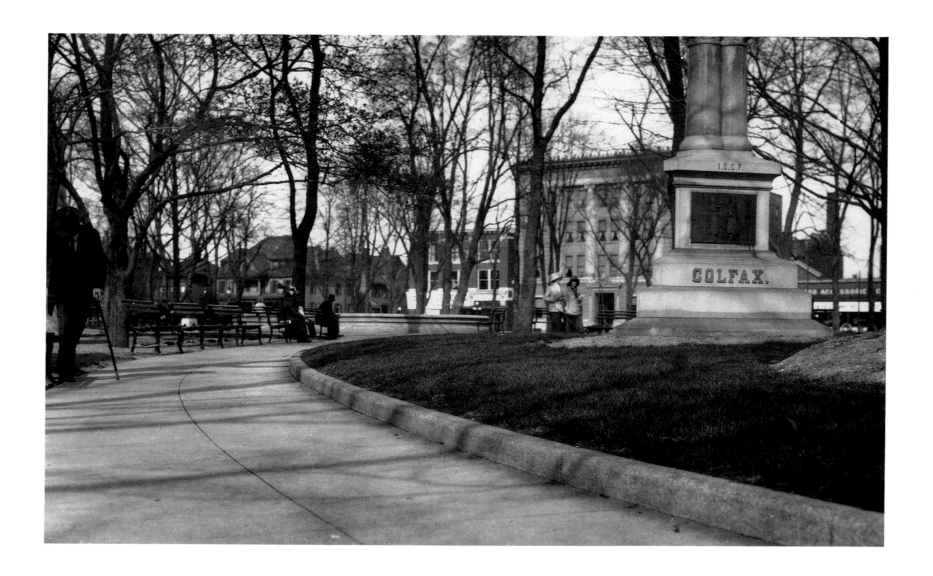

A scene in University Park, Indianapolis. Shown is the base of the bronze statue of Schuyler Colfax executed by Laredo Taft. Colfax served as vice-president during the first term of Ulysses S. Grant. The Colfax statue, occupying a central position in the park, was unveiled in 1887. Statues of Lincoln and Benjamin Harrison also grace the park.

University Park, or University Square, is bounded by Meridian, Pennsylvania, Vermont, and New York streets. The land was initially set aside by the state as a site for a prospective university. A seminary which did not prosper was located there from 1834 to 1836. During the Civil War the square was sometimes used as a drill ground and gathering point for Union soldiers. It was officially declared a city park in 1865.

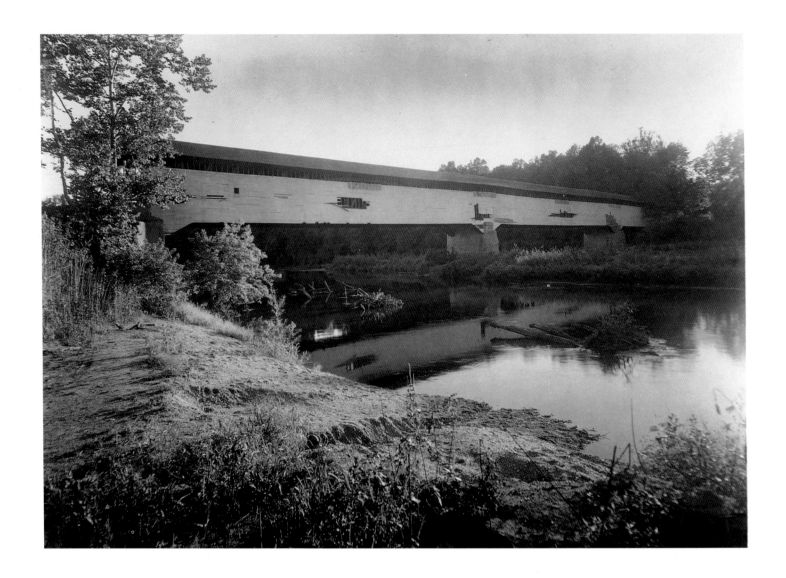

The covered bridge spanning the West Fork of the White River at West Newton in Marion County is shown here in September 1941. The longest covered bridge in the county, at about 484 feet, it was constructed by A. M. Kennedy-Sons in 1880 and was in service until 1950.

According to folktales, bridges were covered to offer shelter from storms to the traveler, or because draft animals were reluctant to cross bridges when the water was visible below. But the roof and siding actually served the more practical purpose of protecting the structural parts of the bridge from rain, snow, and sun and delayed deterioration. The idea of the covered bridge was borrowed from German and Swiss builders.

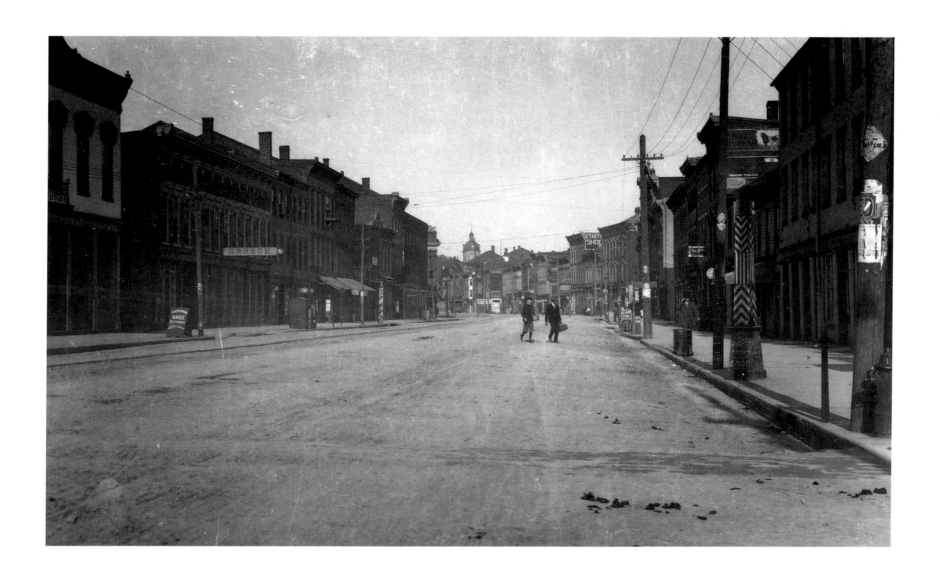

A view of Main Street in Madison, June 1910. Madison is one of the state's oldest cities and has been beautified and preserved through the efforts of Historic Madison, Inc., formed in 1960. More than one hundred city blocks were put on the National Register of Historic Places in 1973.

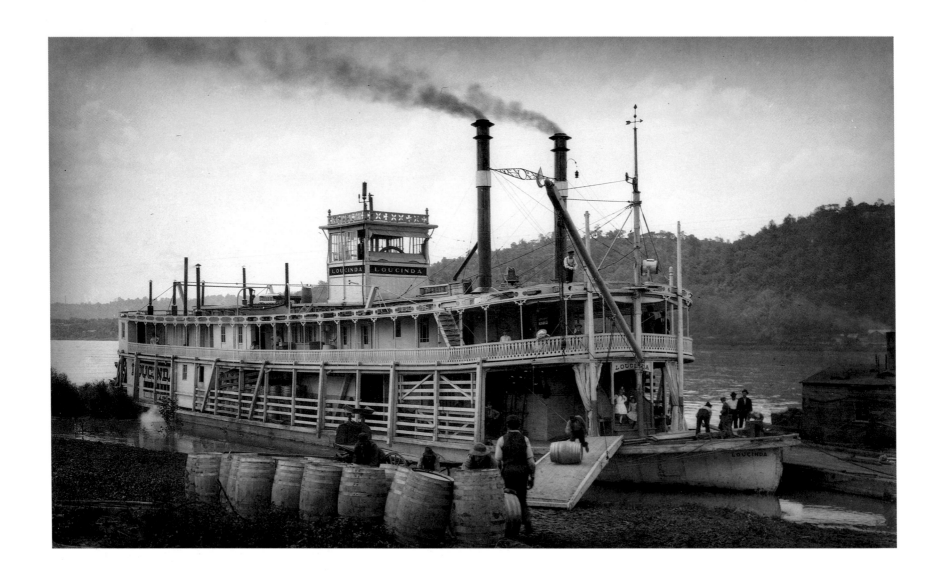

Unloading barrels from the steamboat *Loucinda* at the
Madison wharf in June 1910. The barrels were destined
for the Susquehanna distillery.

This ornate fountain, located in the 400 block on Broadway Street in Madison, has an interesting history. It stood at the entrance of the agricultural building at the Centennial Exposition held in Philadelphia in 1876 to celebrate the one-hundredth anniversary of the Declaration of Independence. At the end of the Exposition, the Madison Odd Fellows purchased the fountain and gave it to the city. It was reassembled at its present location. Through the years, the fountain gradually deteriorated. The city raised the funds to have it recast in bronze in 1980. This photo was taken by Hohenberger in 1926.

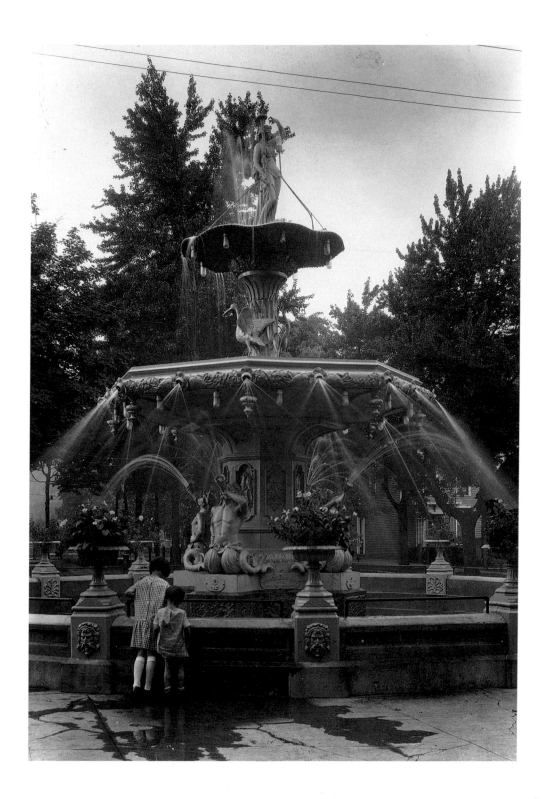

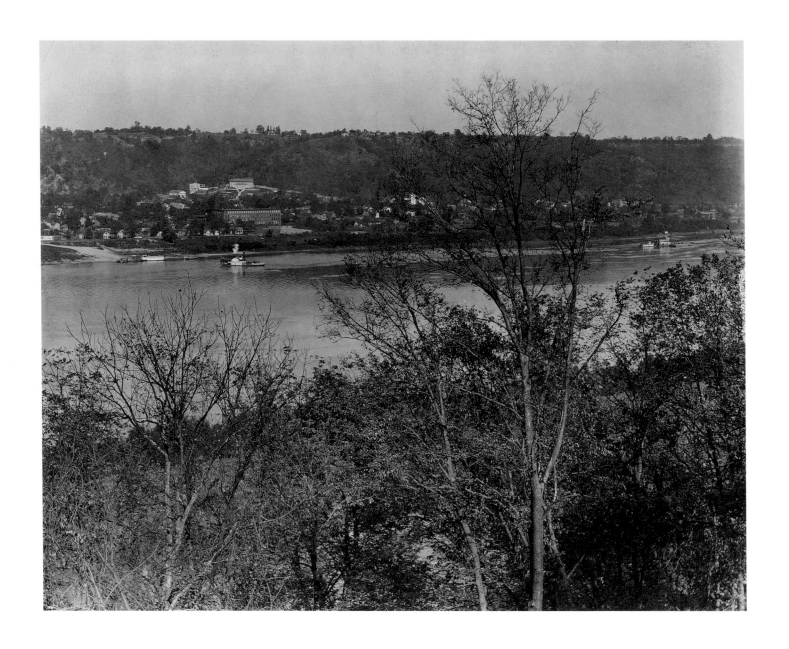

View of the Ohio River and Madison in October 1927, taken from the Kentucky shore. Note ferryboat approaching the landing at Madison.

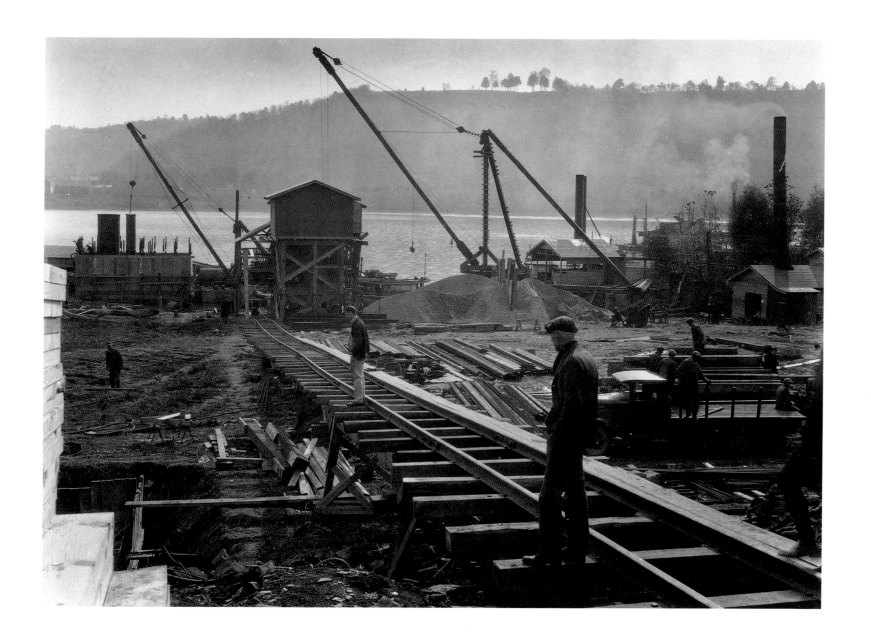

Construction on the first bridge to link Madison with Kentucky.
This photo was taken in October 1928. The bridge was
completed in 1929, and a toll was levied on users for many years.

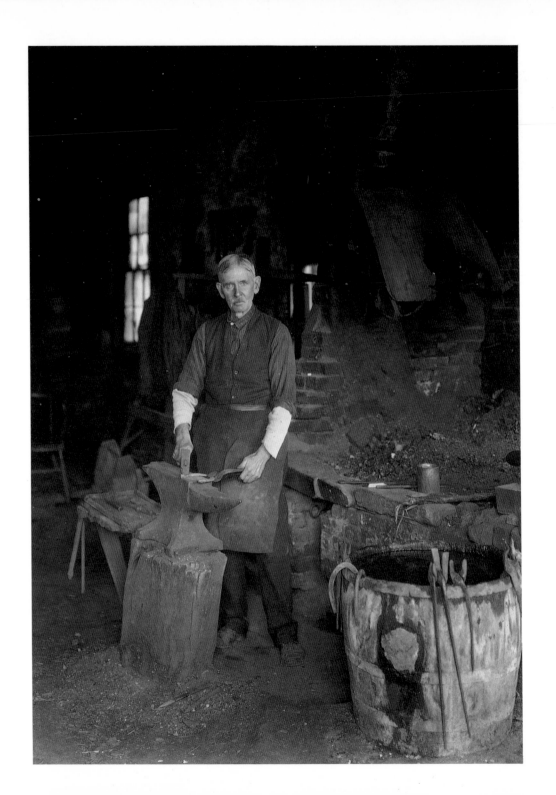

This photo of John Downey, long-time
blacksmith at Madison, was taken in
October 1928.

The portico of the Lanier mansion, completed in 1844 for James F. D. Lanier, an attorney and financier who had moved to Madison in 1817 from North Carolina. Lanier saved the state of Indiana from financial distress during the Civil War by lending the state government more than one million dollars, unsecured, to outfit regiments and meet interest payments on state debts.

Four generations of the Lanier family lived in the palatial mansion before it was acquired by the Jefferson County Historical Society. The Society deeded the home to the state of Indiana in 1925, and it was opened to the public in 1926 as the state's first historical memorial. This photo was taken in October 1920.

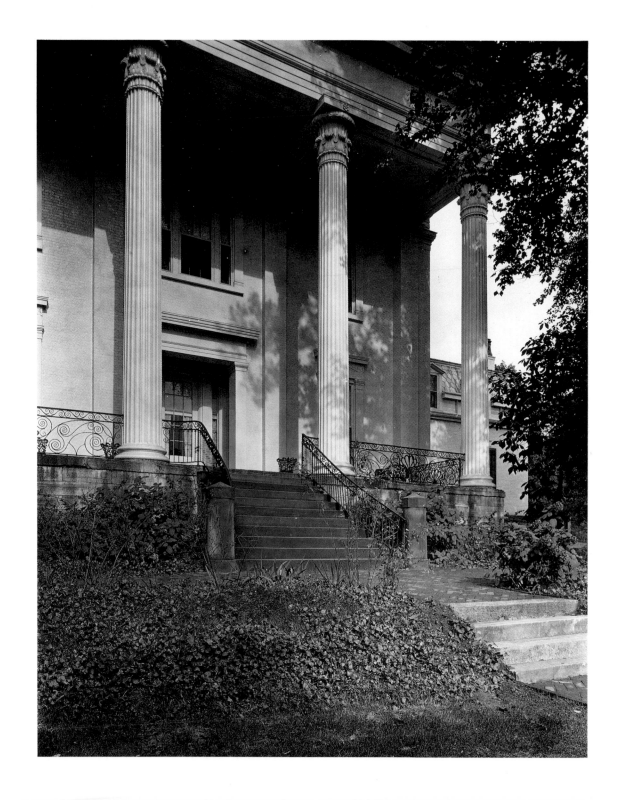

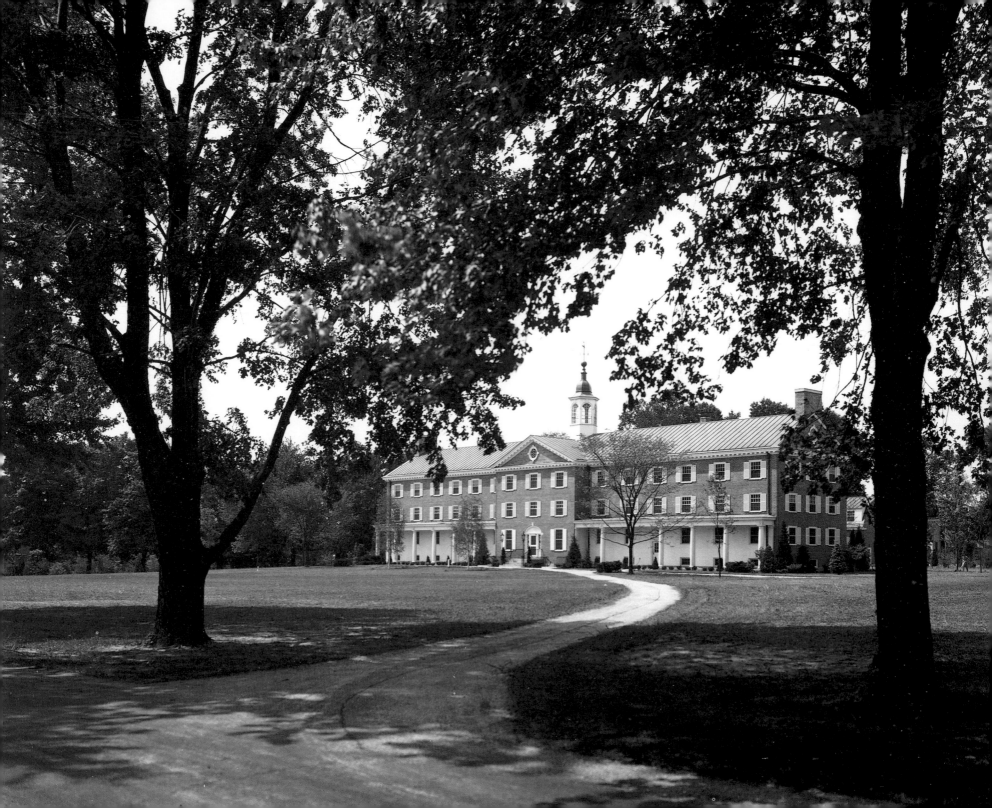

The Donner Residence Hall at Hanover College. The building was donated by William Henry Donner in memory of his son and namesake. The college was founded January 1, 1827, by Presbyterians. Located five miles west of Madison on a promontory overlooking the Ohio River, it is the oldest private college in the state. Hanover is an undergraduate liberal arts college, and is unique in that a large proportion of the faculty and students live on the campus.

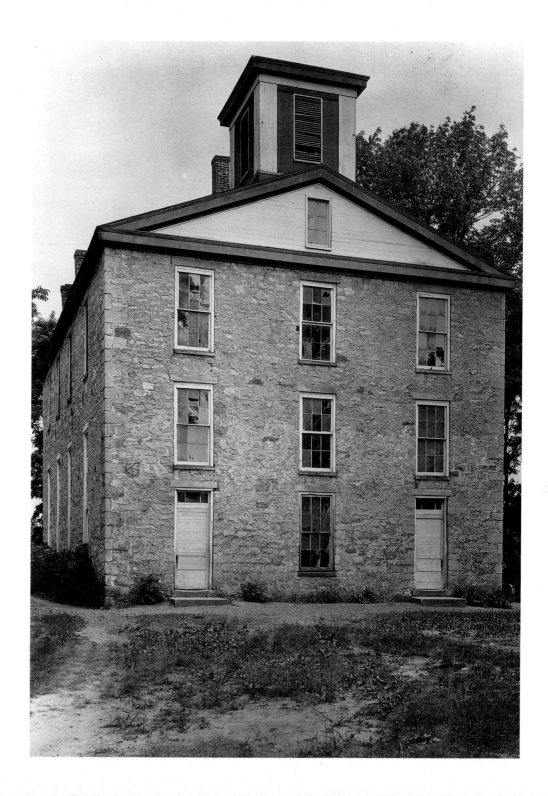

This building, located at Lancaster on State Road 250 near Madison, at one time housed Eleutherian College, founded in 1848 by the Reverend Thomas Craven and others. The college was the first coeducational institution west of the Alleghenies and was open to both blacks and whites. The photo was taken in July 1931. The building was given to Historic Madison, Inc., in 1973 and is appropriately maintained.

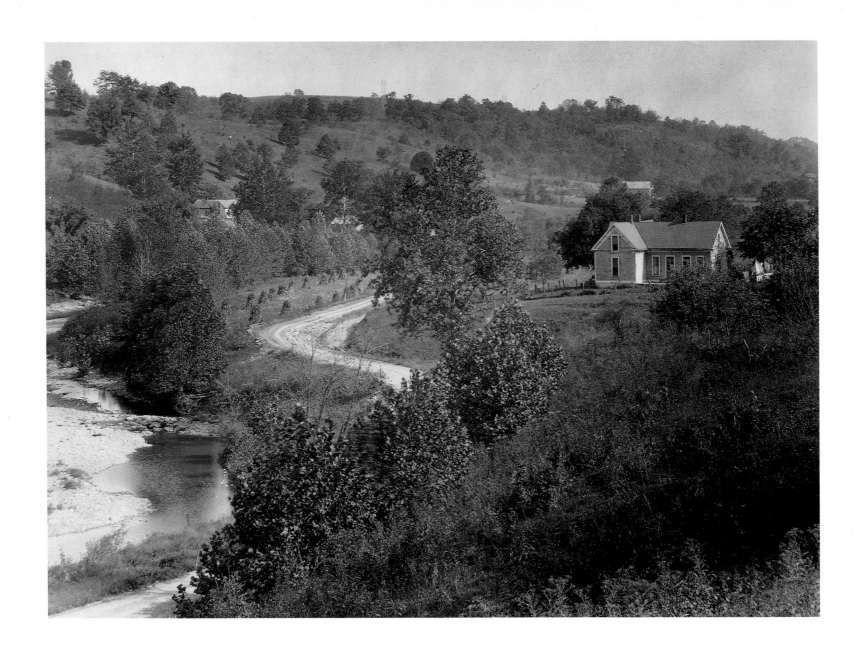

Landscape near Canaan, a village in Jefferson
County, in a photo from 1932.

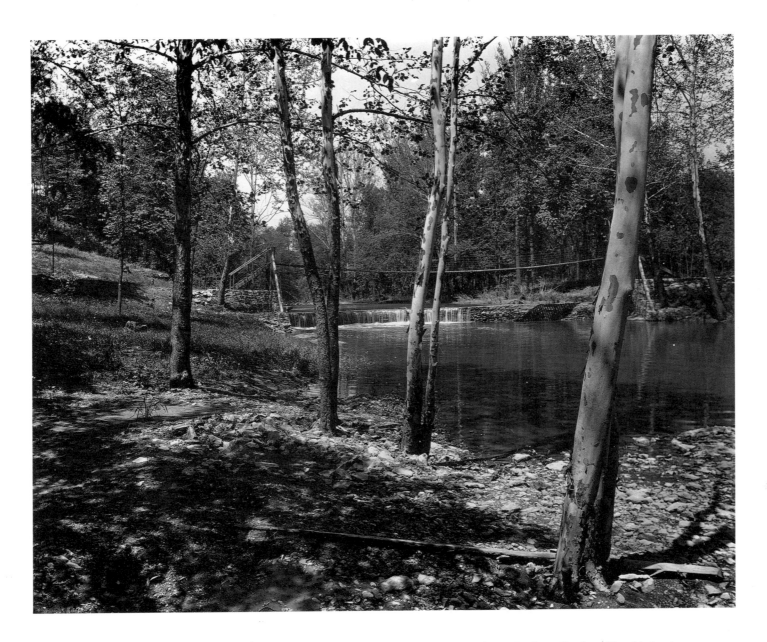

Waterfall and swinging bridge on the estate of Alexander Thomson, located a few miles from New Marion in Ripley County. Hohenberger took a series of photos on the 2,300-acre Thomson estate, including many of "Old Timbers," the home which graced the property. Some of the photos appeared in the *Sunday Indianapolis Star*, December 29, 1940. The Thomson land and home were taken by the U.S. government in 1940 for the Jefferson Proving Grounds, a weapons proving site. Most of the homes on the Proving Grounds were razed, but "Old Timbers" was preserved. It served as a social and recreational center for both military and civilian employees.

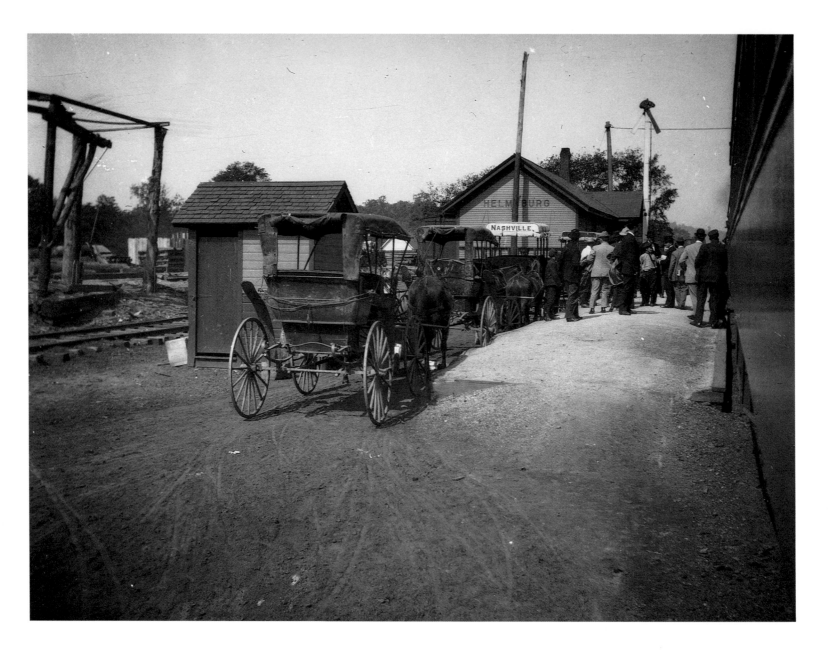

It was difficult to get to Nashville and Brown County before 1906. When the Indianapolis Southern Railroad (later the Illinois–Gulf Central) reached Helmsburg, a village in Jackson Township, Nashville became more accessible. Passenger trains, two each way daily, brought travelers to Helmsburg, where horse-drawn vehicles conveyed them to Nashville. Later the "hacks" were replaced by the automobile.

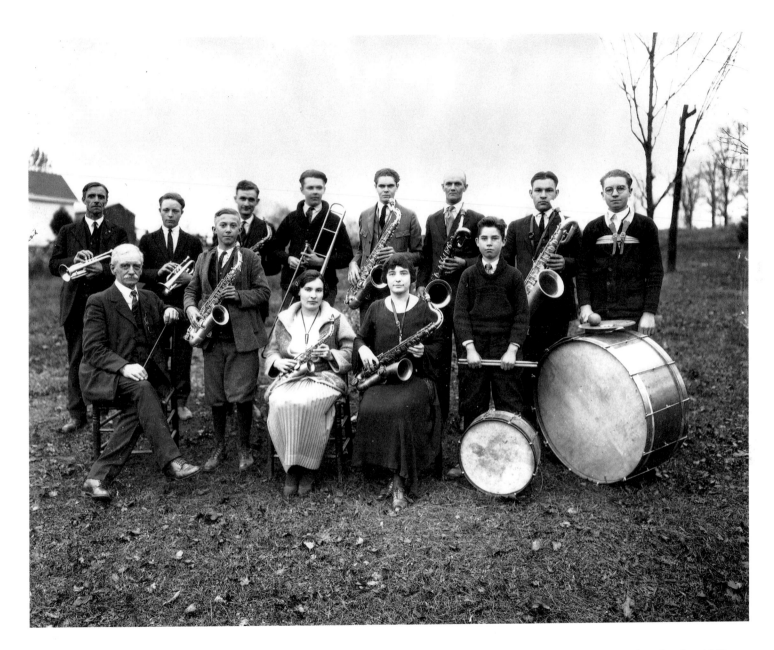

The Helmsburg band in 1923.

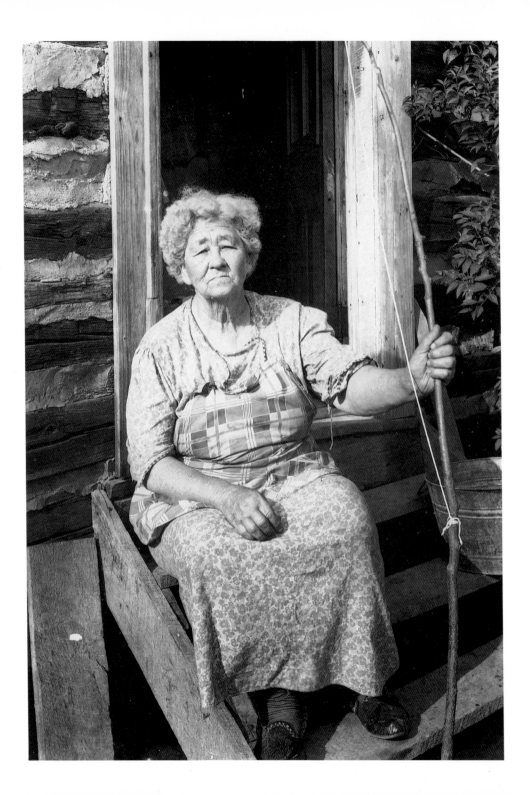

Mary Marshall of Helmsburg, photographed in 1941 when she was seventy-four years of age. She had fished the waters of Bean Blossom Creek for more than sixty years prior to this photograph.

Benjamin Wallace Douglass and his dog, photographed in 1937. Douglass was the owner of Hickory Hill Orchards and cannery near Trevlac. He contributed two articles to the *Saturday Evening Post* (January 4 and 11, 1936), entitled "The New Deal Comes to Brown County, Indiana." The articles were highly critical of the New Deal activities in Brown County relating to land acquisition and new regulations for the canning industry.

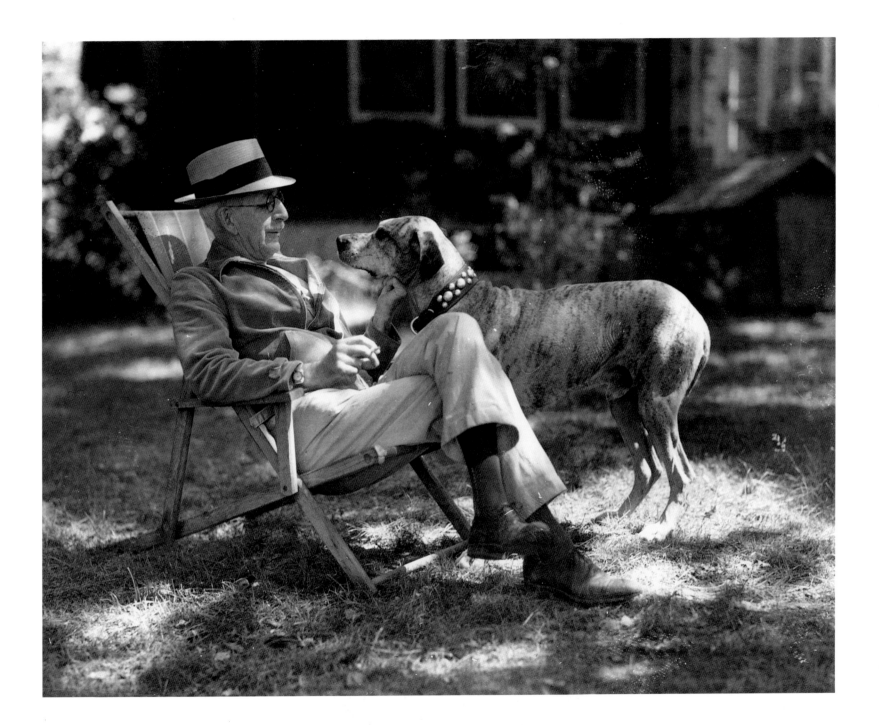

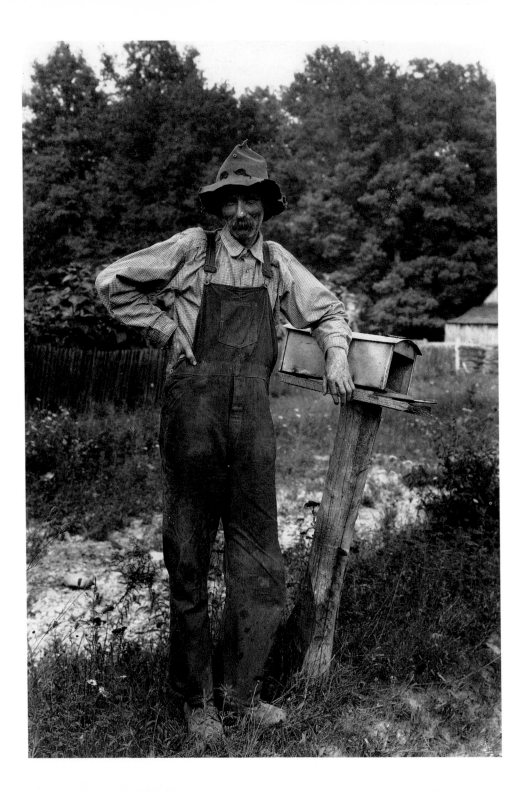

Chris Brummett in 1925. Brummett lived on the family farm in what is today the western part of Washington Township, Brown County, on Dubois Ridge. The farm is now part of Yellowwood State Forest.

Hohenberger methodically sought unsophisticated characters as subjects for camera studies. Chris Brummett was a superlative example. A poor farmer, full of prejudice against city dwellers, education, and society in general, with a crafty native intelligence, he ran for county clerk and was elected, serving 1915–16. He was so inattentive to his duties that the county commissioners had to hire a deputy to carry on the functions of his office.

These "character studies," as Hohenberger sometimes referred to the portraits of rustics, gave hundreds of individuals a temporary reprieve from the oblivion which most mortals suffer on their demise.

This photo, with the log jail in the background, was taken in July 1939. The team, colt, and wagon belonged to Walter (Buck) Stewart. The log jail in Nashville, built in 1879, stands today almost hidden by surrounding buildings. It is still a tourist attraction for those interested in the past.

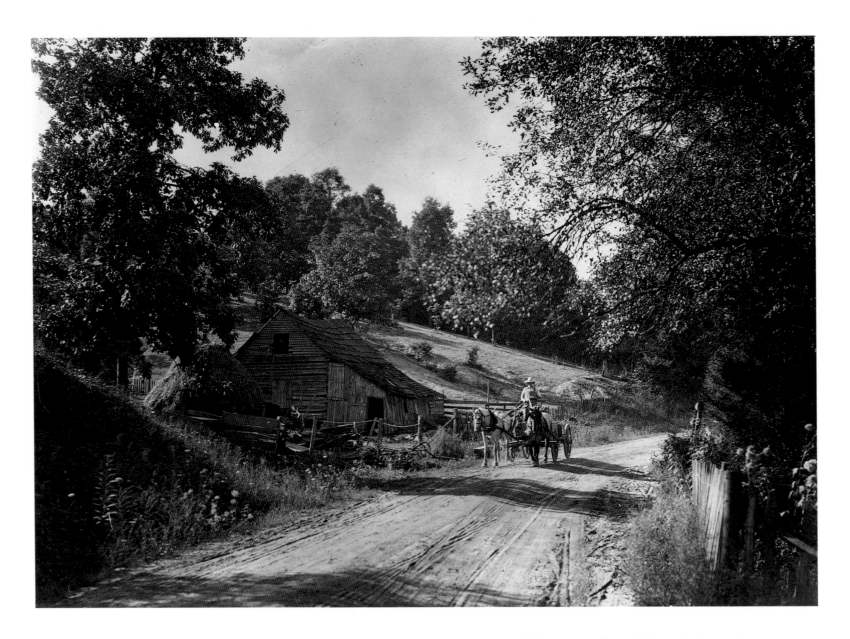

This scenic view, titled "Homeward Bound" by Hohenberger, has always been one of his most popular photographs. The scene was on the Helmsburg Road. The photo was widely reproduced, and Hohenberger sold postcard prints for many years. The negative is undated.

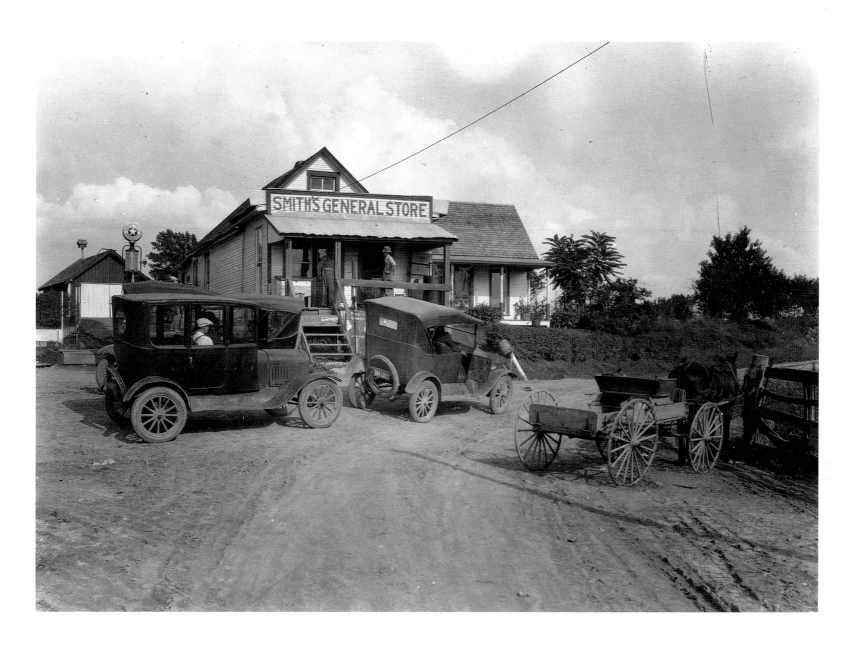

Some came by automobile, some by horse and wagon to make purchases at Smith's General Store. Owned by Minor Smith, it was located at Peoga, a small settlement in northeast Hamblen Township, Brown County. The negative is dated August 20, 1927.

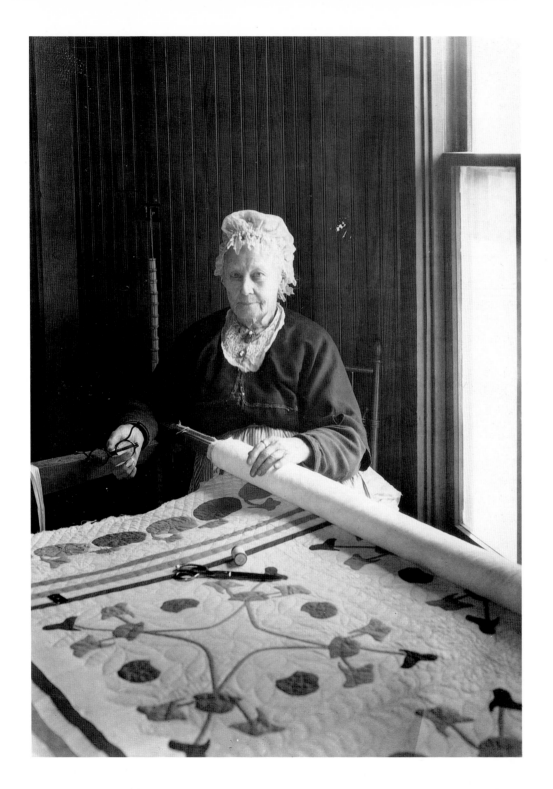

Mrs. Ambrose Bartley, skilled quiltmaker of Nashville, in a 1931 portrait.

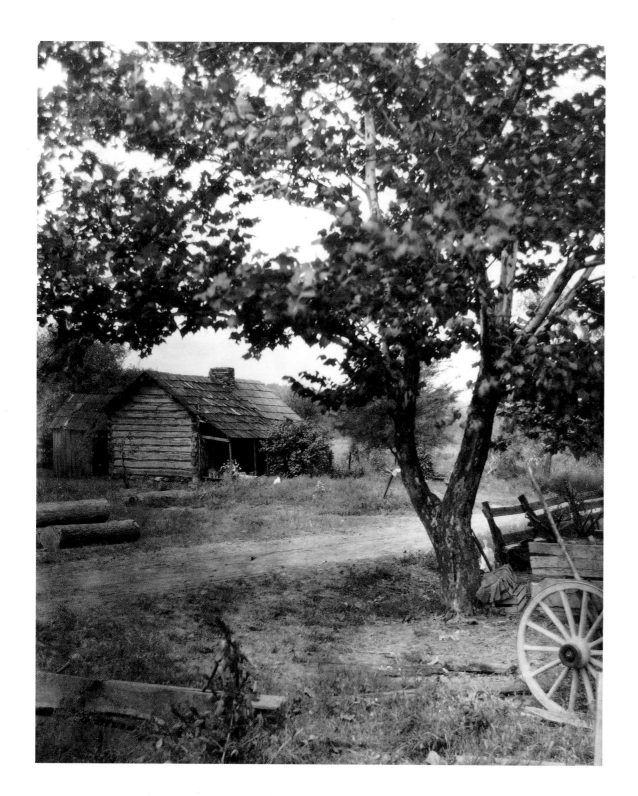

The Bradley home on the
Schooner Road. Travelers pass
through the Schooner Valley on
Highway 46 between Belmont and
Nashville. Hohenberger
photographed nearly every log
cabin home in Brown County.

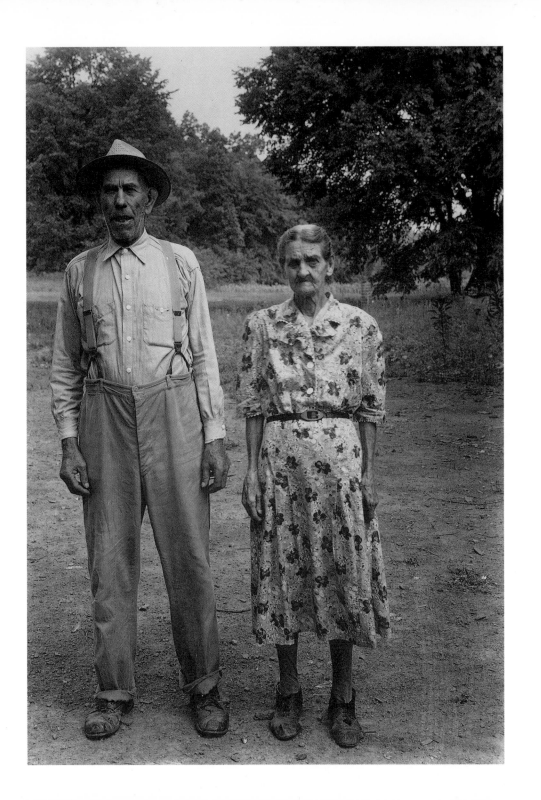

Mr. and Mrs. John Hatchett, photographed in 1944. Hatchett had a small farm south of Nashville.

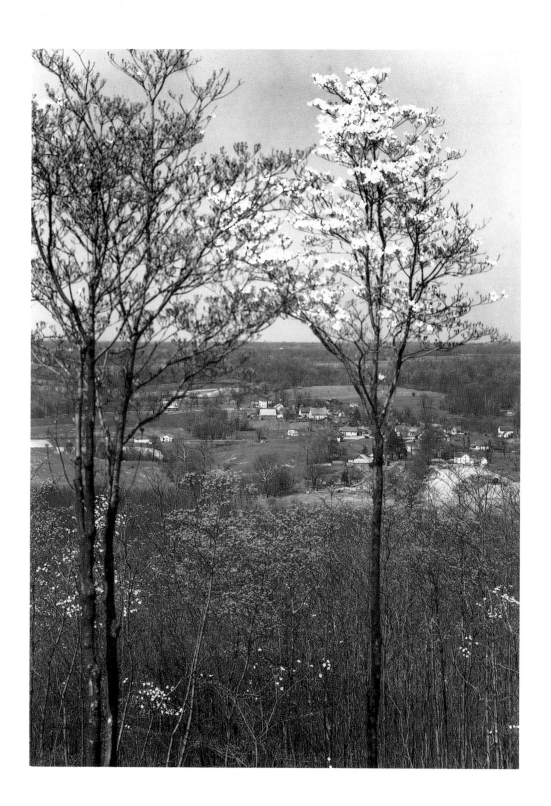

View from the Bean Blossom
overlook on State Highway 135
north of Nashville.
Photographed April 12, 1946,
when the dogwood was in
bloom.

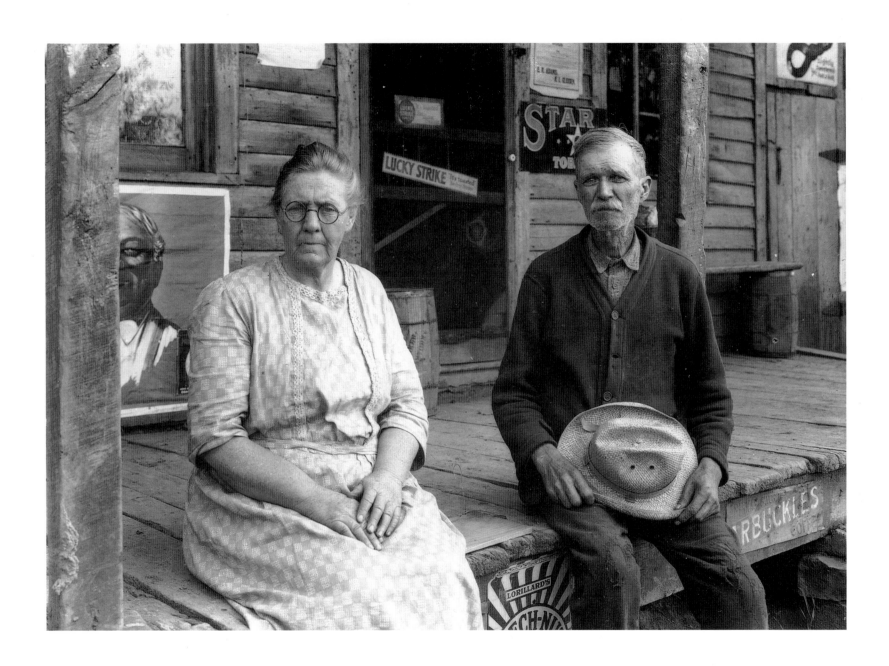

Mr. and Mrs. John Walker, photographed in front of their store in August 1927. The Walkers were long-time storekeepers at Spearsville, a village in northern Hamblen Township, Brown County.

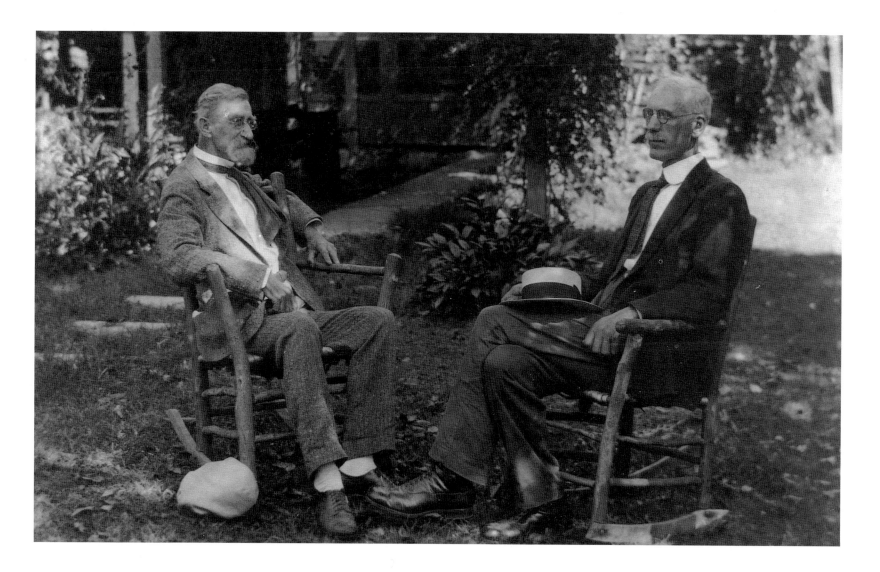

T. C. Steele (*left*) and John Marcus Dickey, about 1922. Dickey had served James Whitcomb Riley as manager, secretary, and biographer. He took up residence in Brown County at Bear Wallow in 1905.

Hohenberger and his camera were frequent guests in "The House of the Singing Winds," the home of Theodore Clement Steele and his second wife, Selma Neubacher. T. C. Steele, born near Gosport in Owen County, was one of Indiana's most celebrated artists. In 1907 he purchased nearly two hundred acres of land in a scenic area one and one-half mile south of Belmont in Brown County. Soon thereafter he built his home and studio on the property, the first artist to take up residence in the county. From that time until his death at home on July 24, 1926, he was the titular leader of the artists' movement in Brown County.

Mrs. Steele gave the estate, his library, and many of his paintings to the state of Indiana in 1945. It is now the T. C. Steele State Historic Site, open to the public.

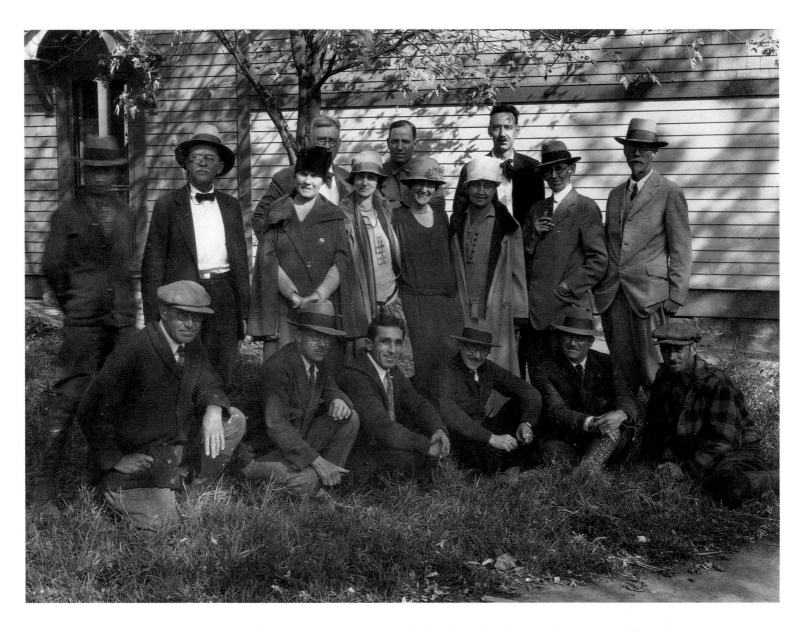

Local and visiting artists pose at the Nashville Gallery, October 16, 1927. *Front row, left to right:* Homer Davisson (Ft. Wayne), L. O. Griffith, V. J. Cariani, C. Curry Bohm (Nashville), Charles Dahlgreen (Oak Park, Ill.), George Mock (Muncie). *Second row, left to right:* Edward K. Williams, Ada Walter Shulz, Musetta Stoddar, Marie Goth (Nashville), Lucy Hartrath (Chicago), Robert Root (Shelbyville, Ill.), Adolph Shulz (Nashville). *Third row, left to right:* Will Vawter (Nashville), Paul Sargent (Charleston, Ill.), Carl Graf (Indianapolis-Nashville).

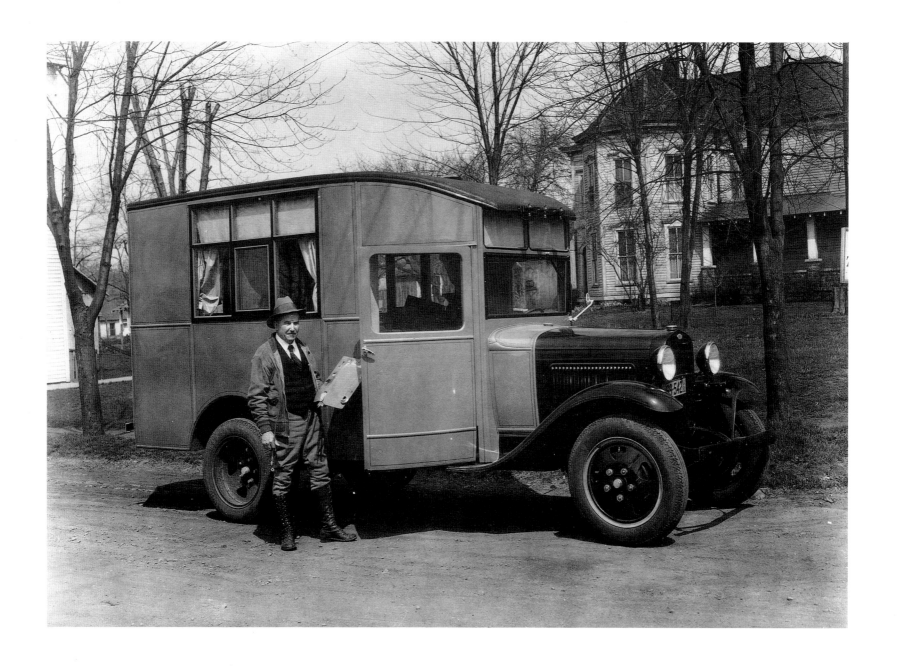

Artist Charles Dahlgreen from Oak Park, Ill., and his traveling studio. Photo taken April 1931.

"The Liars' Bench," the most famous and best-selling photograph taken by Hohenberger. The bench was a place of tall and impossible tales and was strategically located on the lawn of the Nashville courthouse, so that the occupants could see and be seen. It was known as the Liars' Bench long before this photo was taken, but it became nationally famous after prints were circulated. Hohenberger bristled at the suggestion that it was posed, saying such a question "spoils the effect of my work of course."

The photo was taken in 1923. It may be noted that the heads of the "liars" are turned slightly to the right. Oral tradition has it that the six men were looking at a lady dismounting from a parked automobile.

Don Herold, Hoosier writer and artist, wrote Hohenberger in 1941 concerning two of his prints which he had framed. "One is a bunch of old codgers sitting on a bench, developing their personalities. People sometimes ask me why Indiana produces so many writers. I answer that we know how to sit around and ripen our souls, out there."

Hohenberger gave the "liars" false names concocted from their actual names. From left to right, real names in parentheses, the bench occupants were Mosey Scott (Scott Moses), Woody Jackson (Jack Woods), Hen Budderson (Richard M. "Bub" Henderson), Andy Simpson (Sam Anthony), Corey Help (Harry Kelp), and Cal Duard (Duard Calvin).

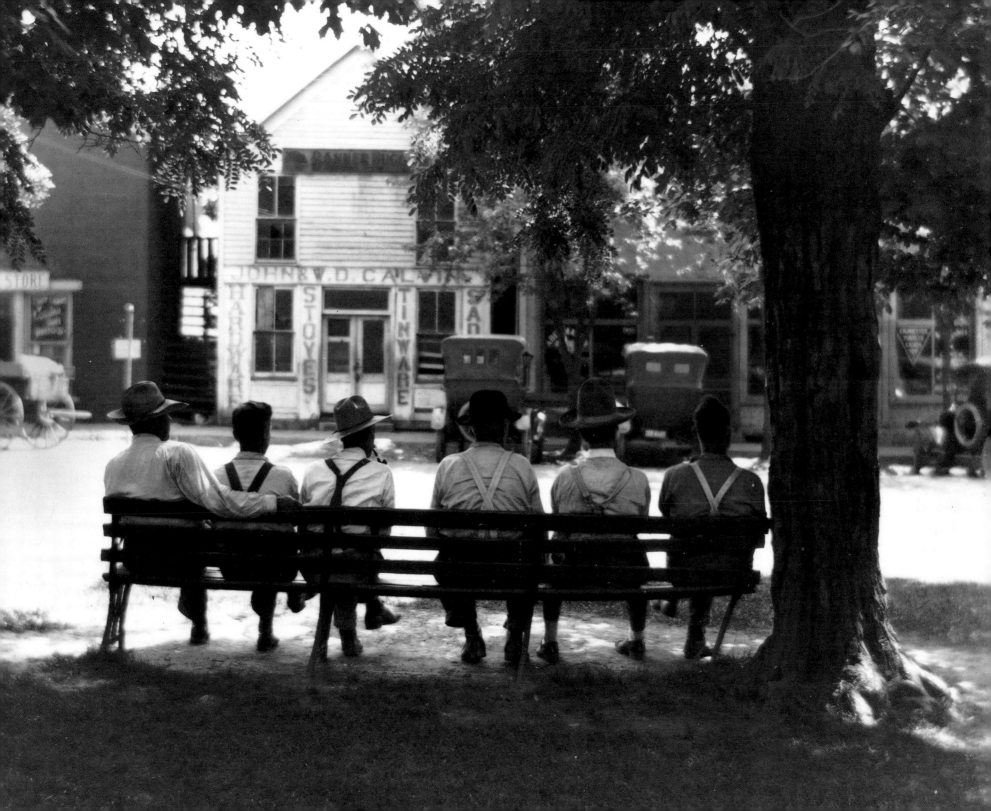

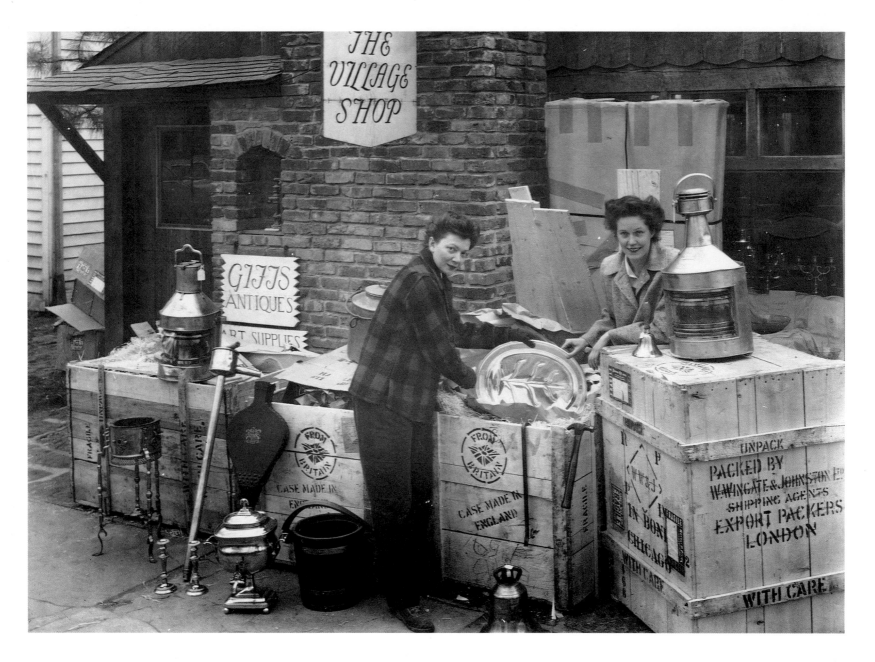

The owners of the Village Shop on Van Buren Street in Nashville unpack foreign imports in 1950.

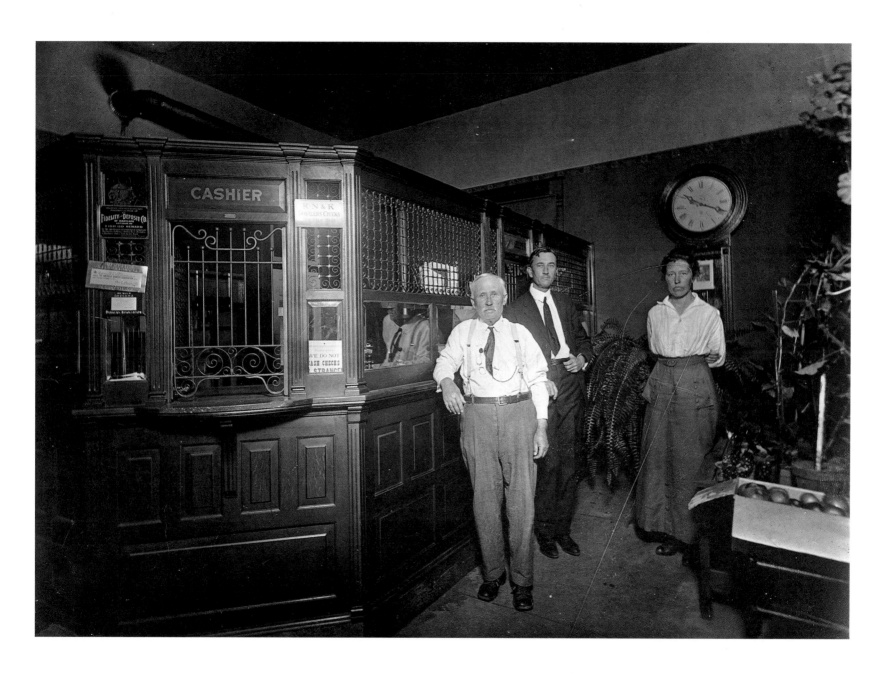

The Nashville State Bank on West Main Street. *From left to right:* James L. Tilton, president; William Coffee, cashier; and Olive Kelp, bookkeeper.

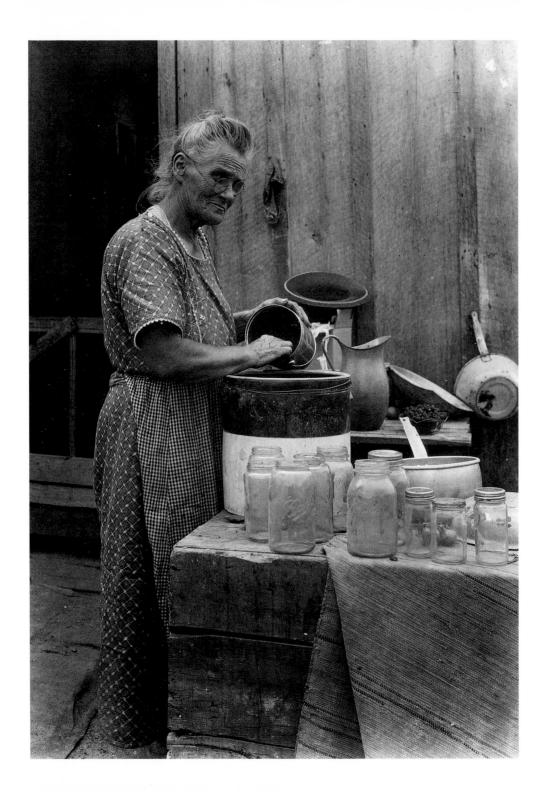

Mrs. McDonald canning blackberries
in Nashville in 1926.

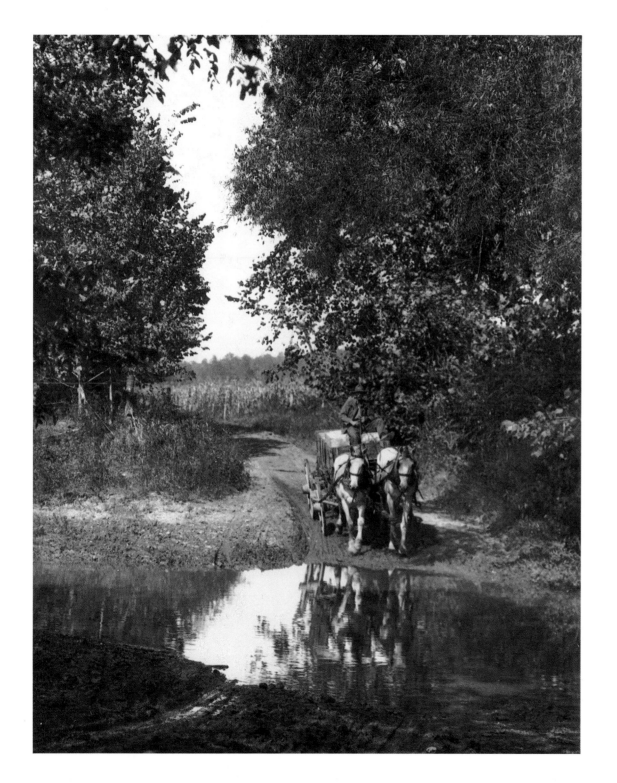

Driver and team crossing ford on
Bear Creek Road in Brown County.

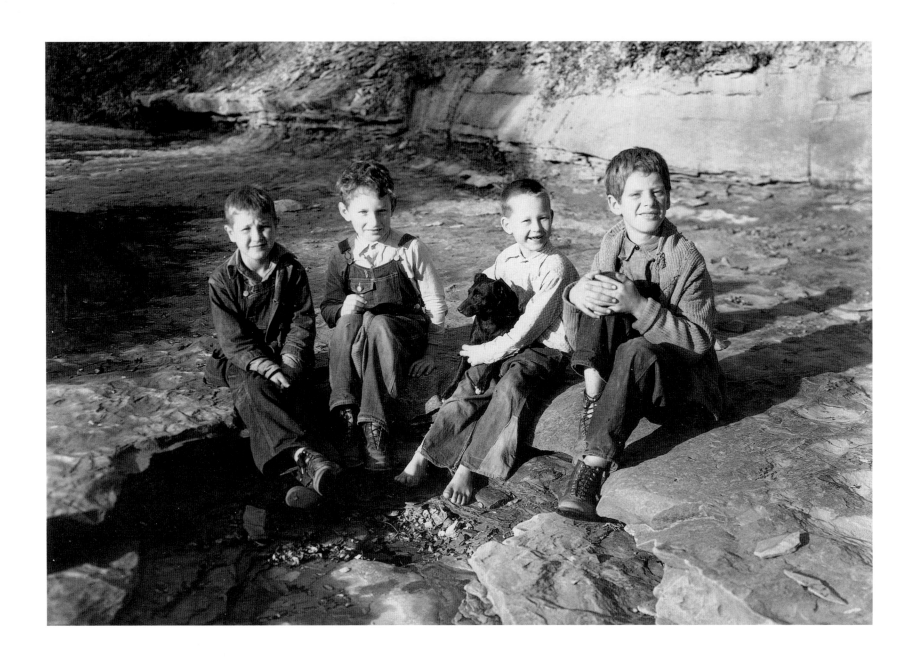

Four Brown County boys photographed in
1931 on Jackson Creek.

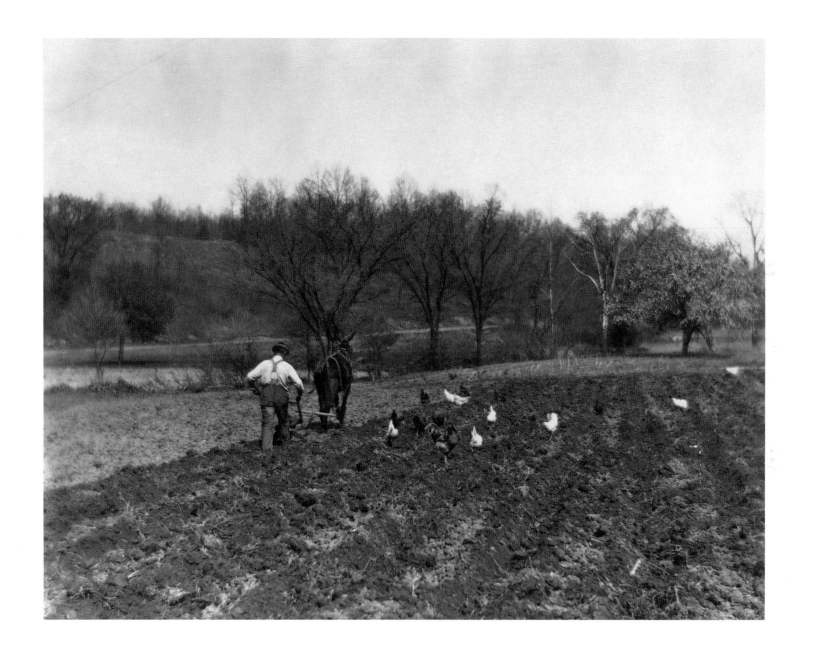

Chickens follow a plow which is unearthing hidden treasure in the form of earthworms. The man behind the plow is "Mr. Chafin" of Brown County. The photo is dated April 1922.

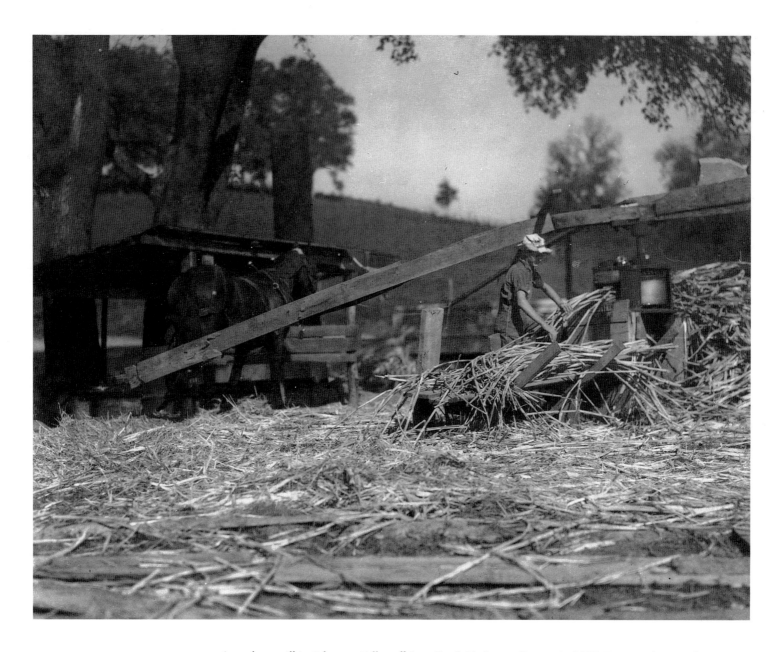

A sorghum mill in Schooner Valley off State Road 46, Brown County, in 1937. Pressing the cane for its juice is the first stage, after harvesting, in the making of sorghum molasses. The juice is then boiled, with much stirring to avoid scorching, until the desired consistency is reached. A thick sorghum molasses is slow in pouring, giving rise to the disparaging description of someone as being ''slow as molasses.''

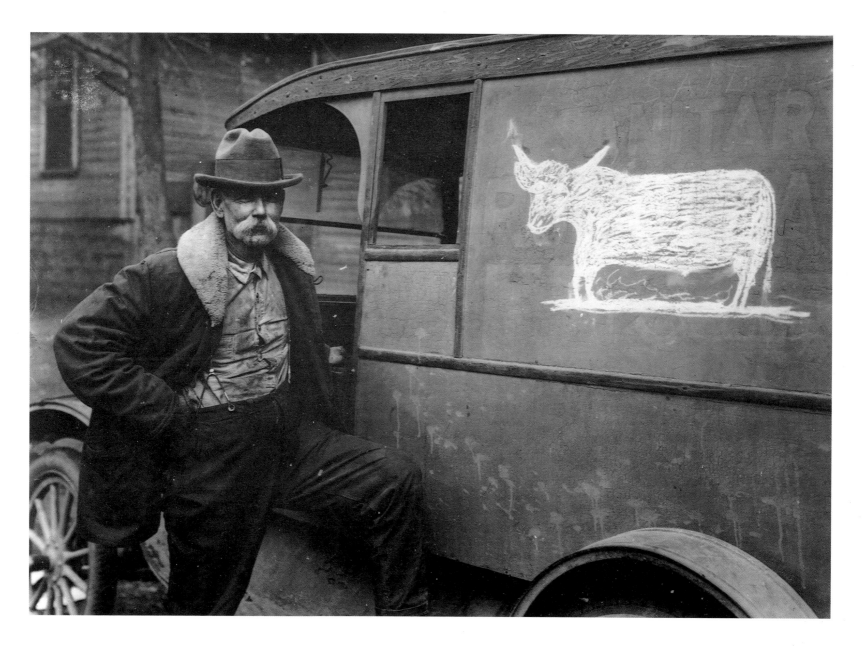

Clark Campbell sold beef from this truck for many years in Nashville and Brown County. He slaughtered his own beef and sold only in the cooler months because his truck was not refrigerated.

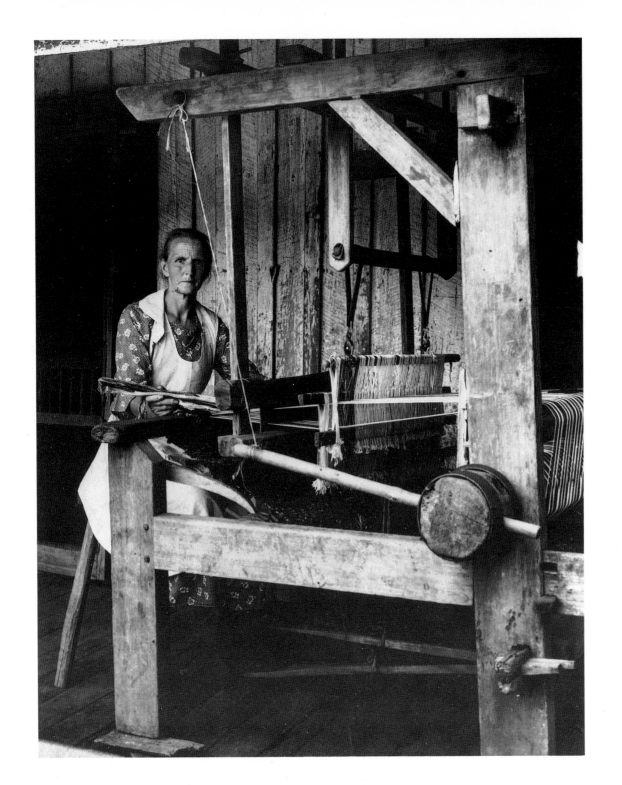

Iva Lucas lived on Crooked Creek in Brown County and was known as a competent weaver.

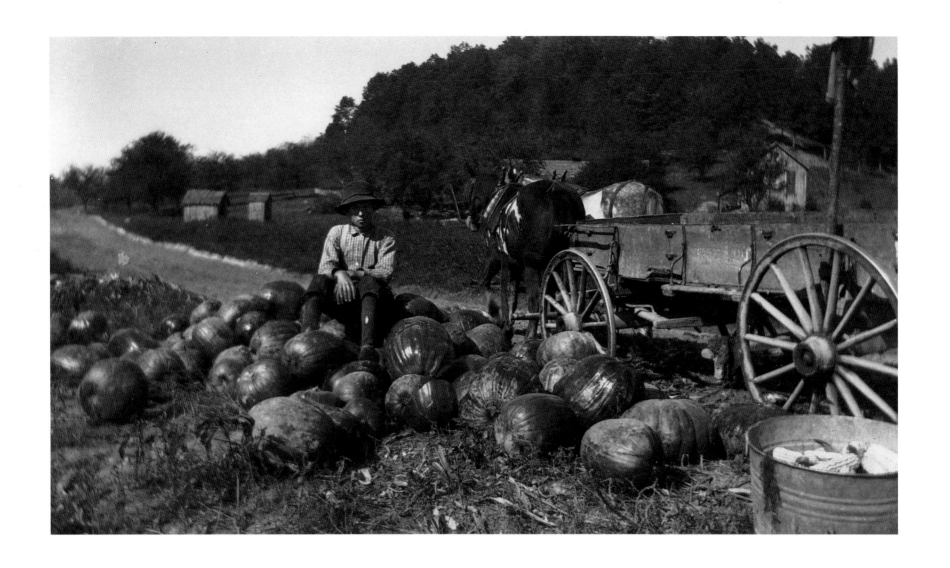

A youthful entrepreneur selling pumpkins
along the roadside in Brown County.

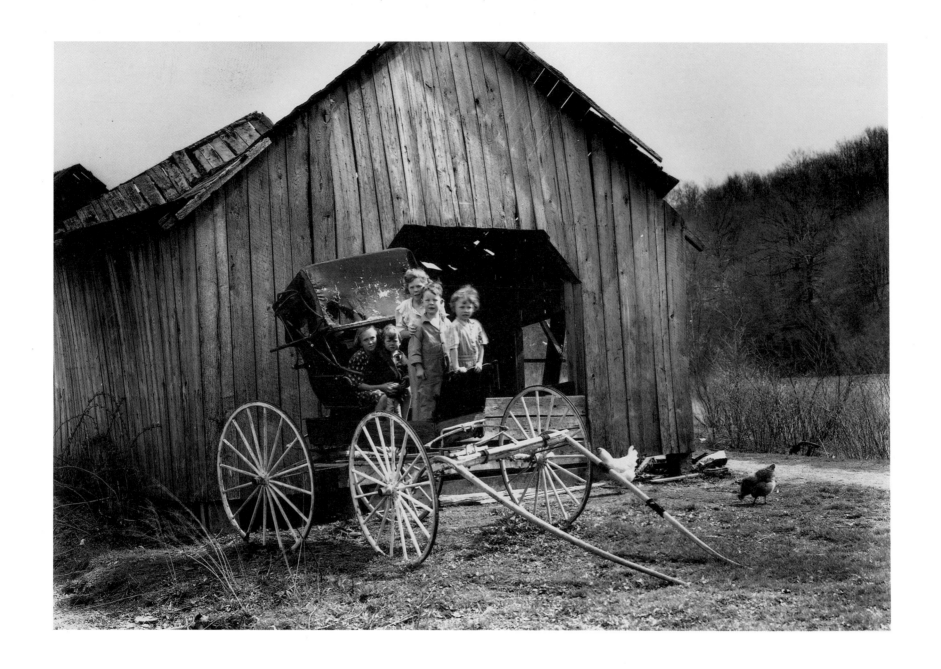

Children in an old buggy along State Road 46
east of Nashville, photographed in 1947.

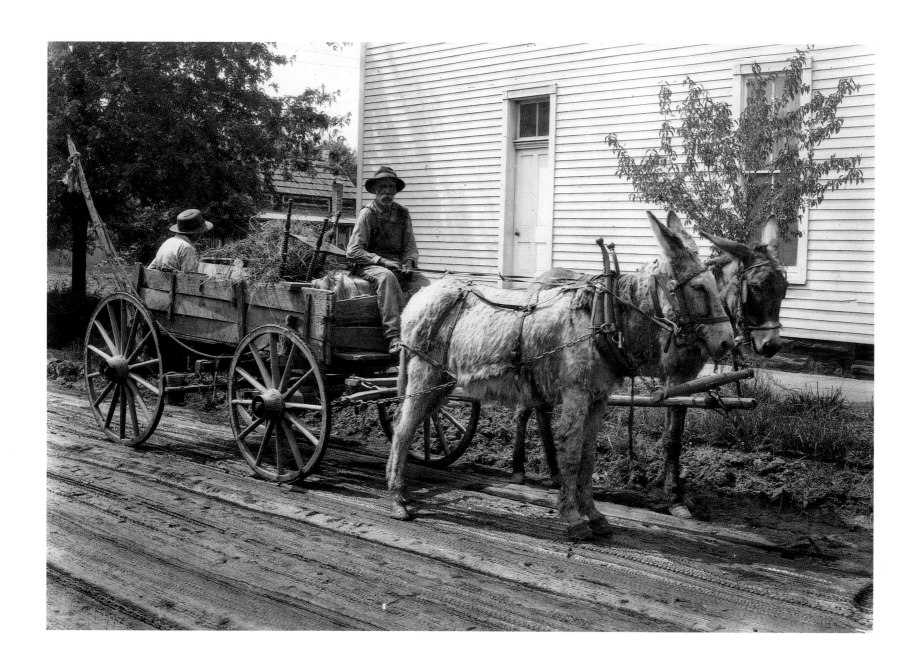

Dave Hardin and his wife Liza were transported around Brown County in this wagon pulled by two burros in 1927.

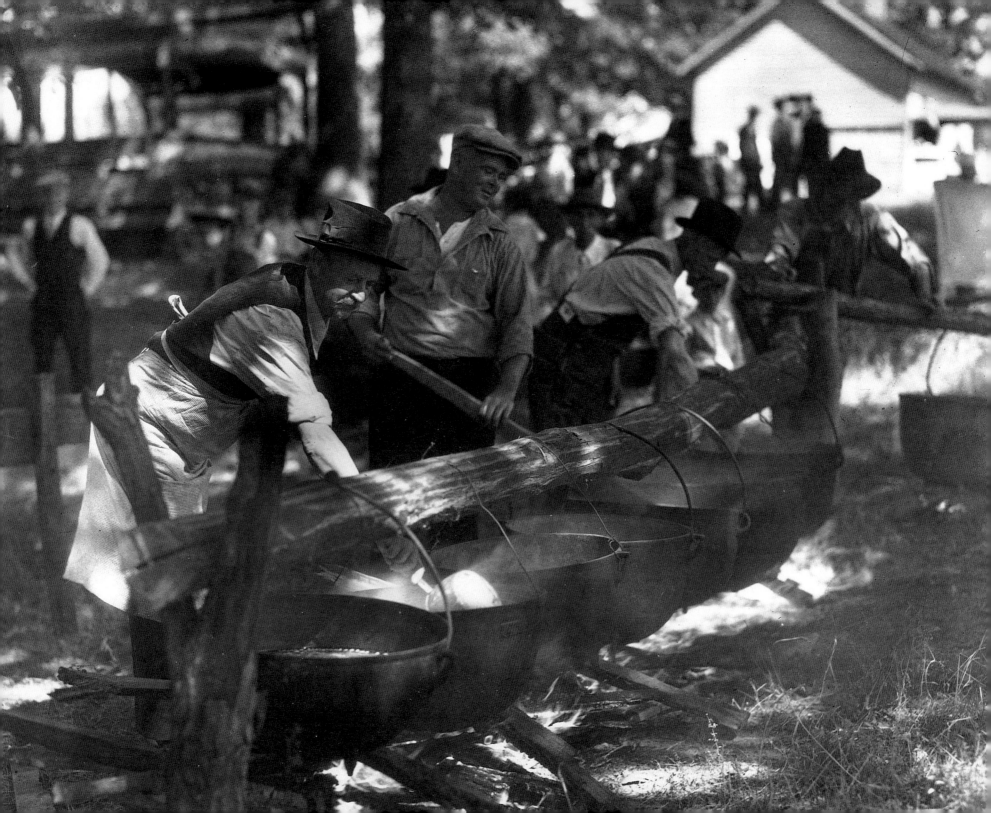

Cooking the beans for Brown County's annual Bean Dinner in 1931. This annual event, to commemorate veterans of the Civil War, was first held in the Schooner Valley cemetery in August 1887.

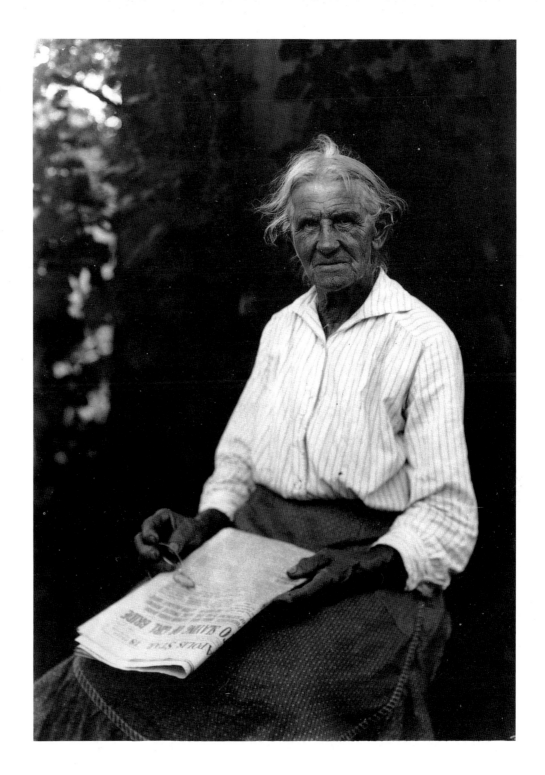

Molly Lucas posed with the *Indianapolis Star* in 1923. Molly was a likable spinster who lived in Nashville and made her living as a laundress and assisting her sister, Allie Ferguson, who ran a rooming and boarding house in the village. Molly befriended several acquaintances and became an honorary aunt to many. Hohenberger recorded many of her observations and pithy remarks in his diary.

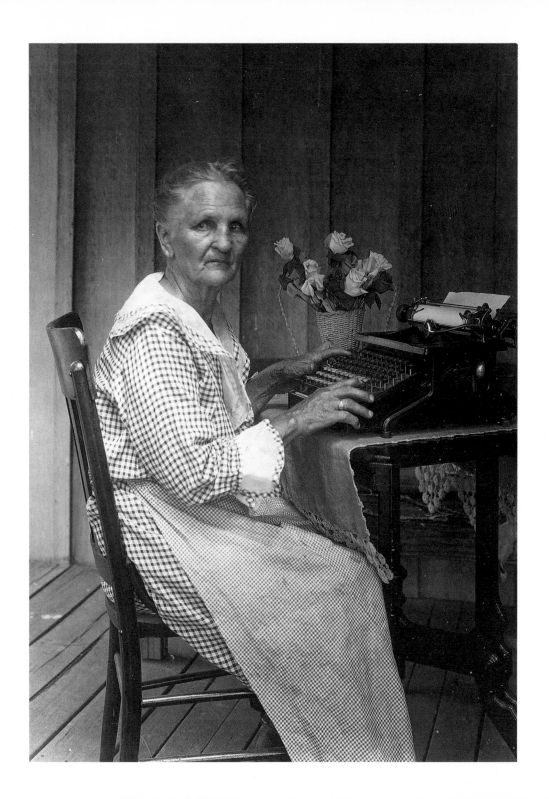

Amanda Mason, who ran a boarding
house in Nashville, photographed at the
typewriter in 1926. Hohenberger recorded
in his diary July 31, 1926: "Amanda
Mason. Took photograph of her . . . at
typewriter, which she has operated for
12 years. Sends out three letters a week.
. . . Insisted that the paper flowers which
Vernie made should be in the picture.
Used to be a good writer but took up
typewriting and 'forgot' how to write
longhand. Wanted time to comb hair
before being photographed.''

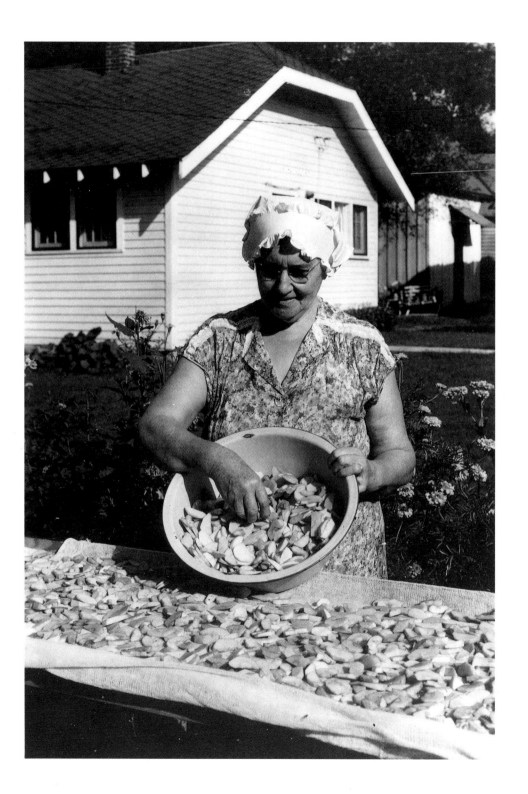

An unidentified Nashville woman drying apples.

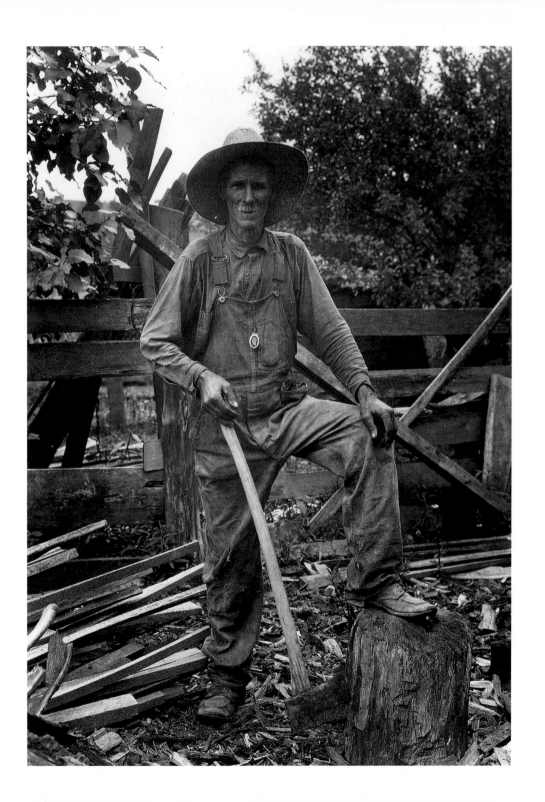

Washington Barnes poses for a photo in 1926. Barnes and his wife lived on the east branch of Owl Creek northwest of Nashville. Mary Barnes (Grandma) was a frequent subject for portrait artists. Washington made brooms by hand and peddled them on the streets of Nashville.

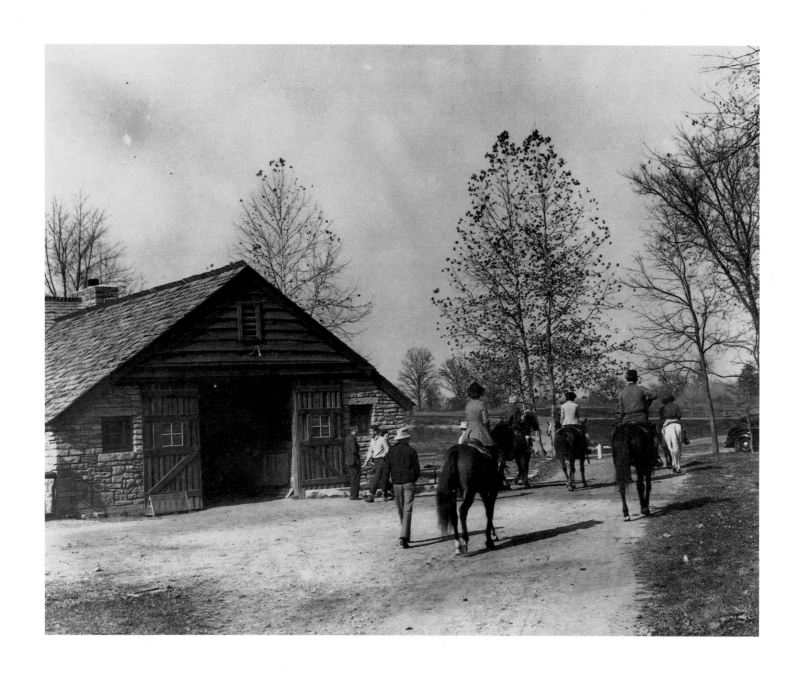

An undated photo of the riding stables in
the Brown County State Park.

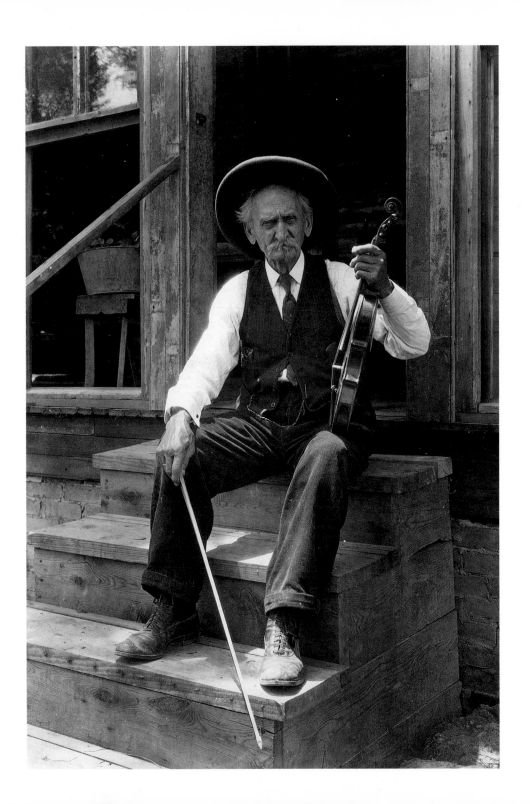

Jim Major, Brown County fiddler, in 1927.

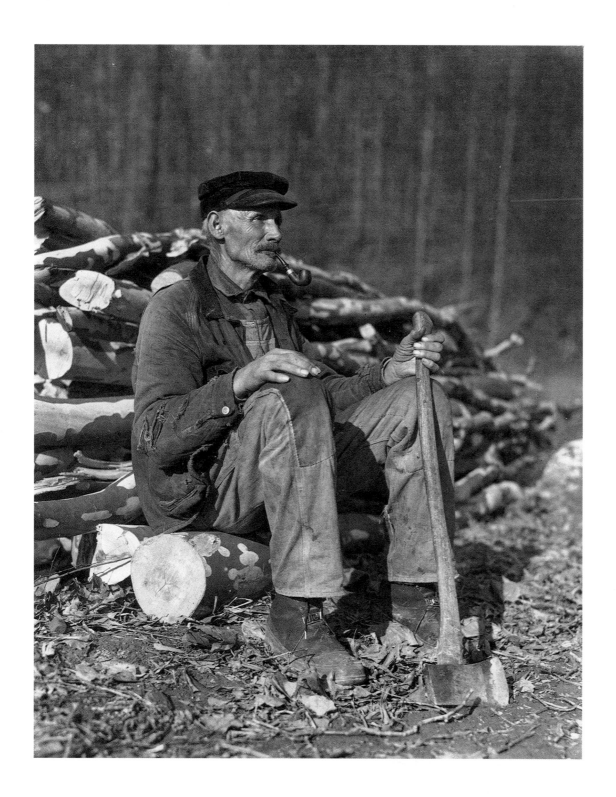

Charles Taylor, photographed in 1931.
Taylor lived west of Nashville on Owl
Creek on a small farm. At one time he
operated a gristmill east of the Nashville
courthouse.

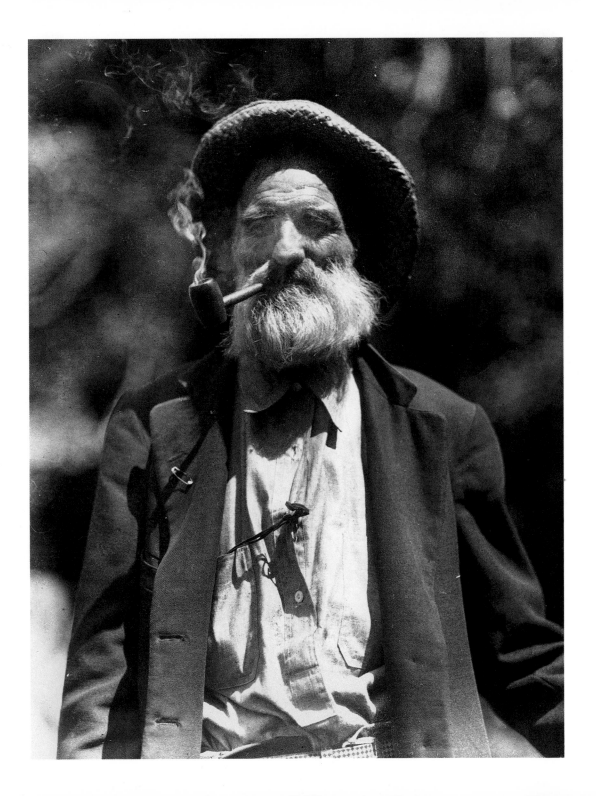

Alexander Fleener, photographed at the Old Settlers Festival in 1931. This annual event has been held since 1877 to honor the pioneers of Brown County. It is now held at Clupper's Grove, near Bean Blossom, on Friday night and the following Saturday. A carnival atmosphere prevails which attracts crowds in the thousands.

The Motor Maids of America, a national organization, held a two-day meeting in July 1947 in Nashville. The ladies competed in a series of obstacle courses and acceleration races. This photo was taken at the Singing Pines, a motel on East Main Street which no longer exists.

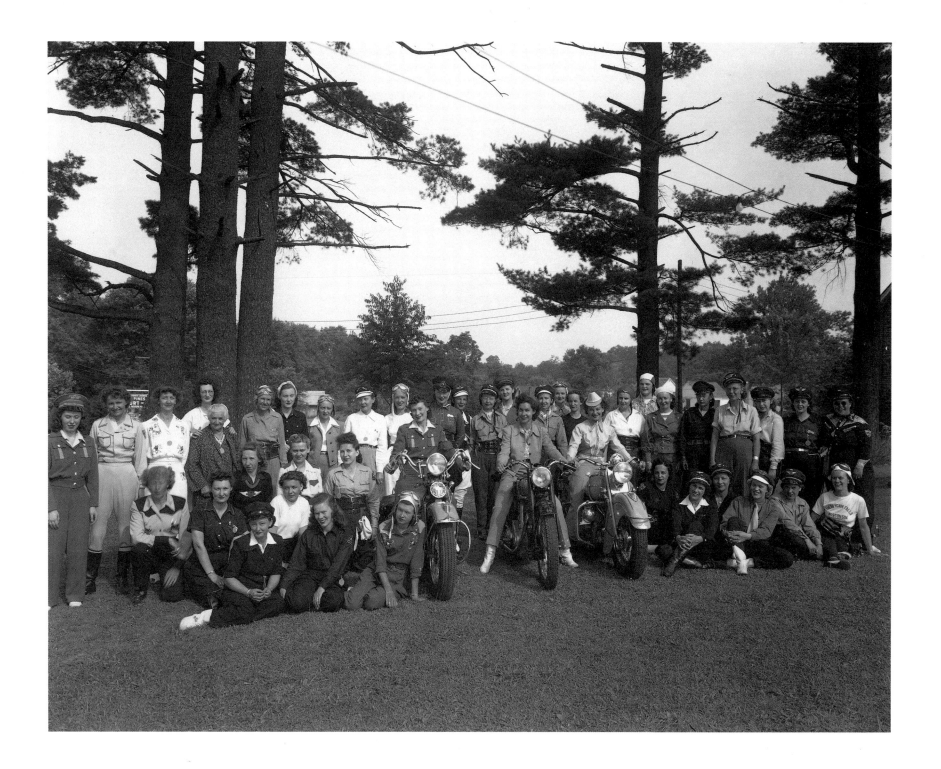

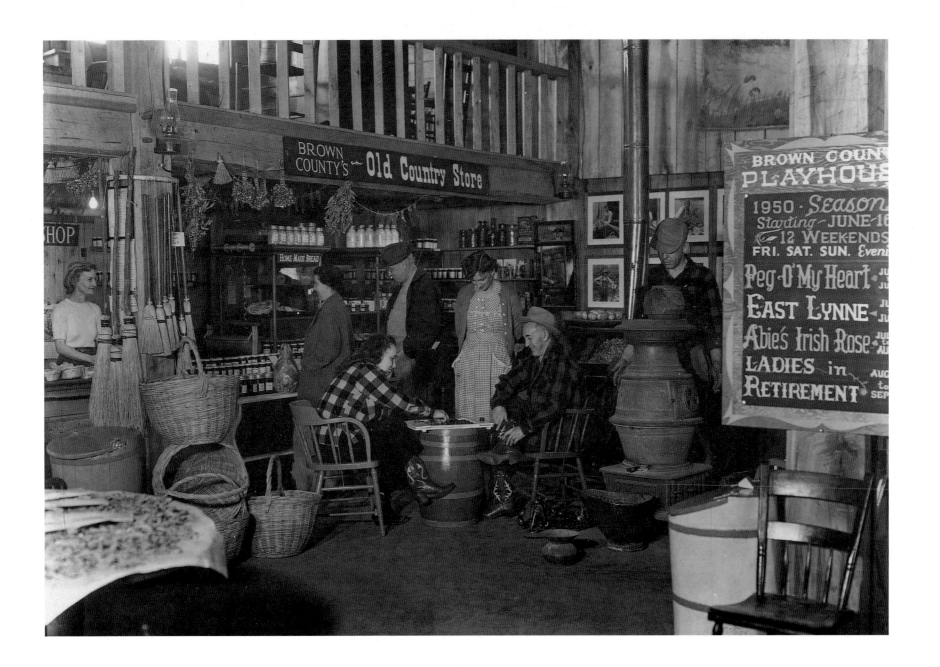

An interior view of the Old Country Store in Nashville, taken February 20, 1950. This photograph was most certainly posed. The woman standing between the players is Nota Neumister; standing to her left is A. J. Rogers. Marjorie Schmidt is playing against an unidentified man. Reba Hutchinson stands behind the brooms. Beyond the stove, a few of the many Hohenberger photos which adorn the wall can be seen.

This photo, taken June 3, 1929, was given the title "Motherless Home" by Hohenberger. A widower and his three daughters stand before their cabin door. The corn above the door might be considered decorative, but may have been seed for the next planting.

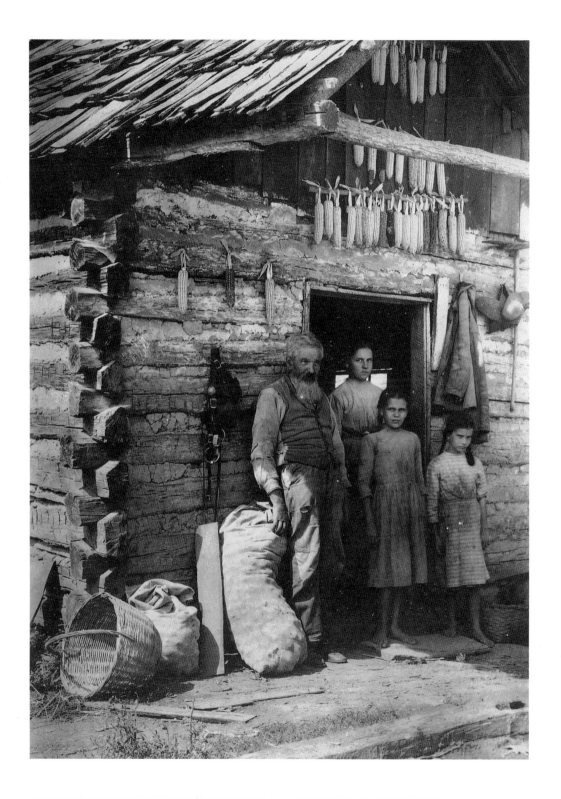

The birthplace of Edward and George Eggleston in Vevay. The house stands at 306 West Main Street. This photo was taken in June 1924. The Eggleston brothers were important Indiana literary figures. Edward was a minister, editor, historian, and novelist, and is probably best known for *The Hoosier Schoolmaster,* published in 1871. His younger brother George was a lawyer and newspaper editor and wrote more than forty romantic novels during his lifetime.

Vevay has preserved most of its early homes and buildings. The area was initially settled by Swiss immigrants as early as 1802. In 1813, Jean François Dufour and his brother Jean Daniel laid out the town of Vevay. The pioneers from Switzerland terraced the hilly countryside for their vineyards and produced wine as a chief article of trade for a number of years. During the town's heyday as an exporter of agricultural products, it was one of the principal river ports on the Indiana side of the Ohio River.

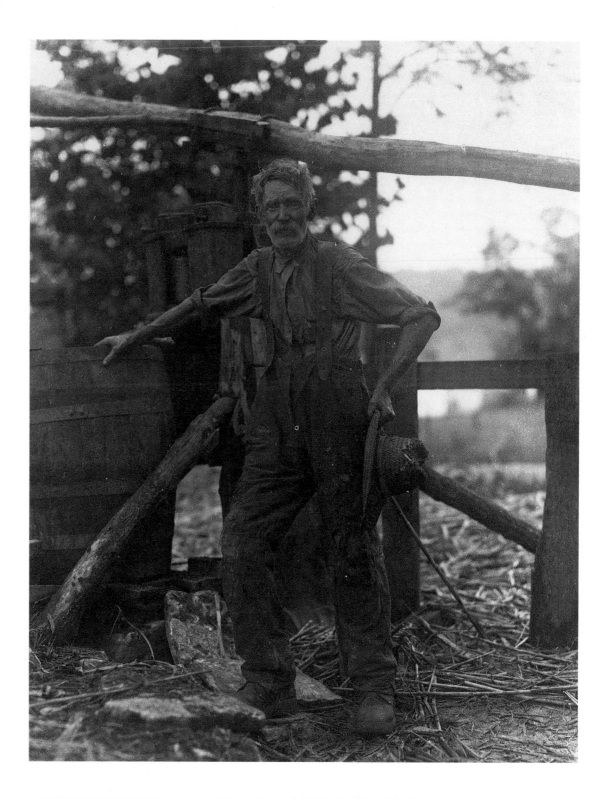

R. B. Banes, sorghum maker in the village of Long Run near Vevay. Mr. Banes was seventy-six years old when this photo was taken in 1932.

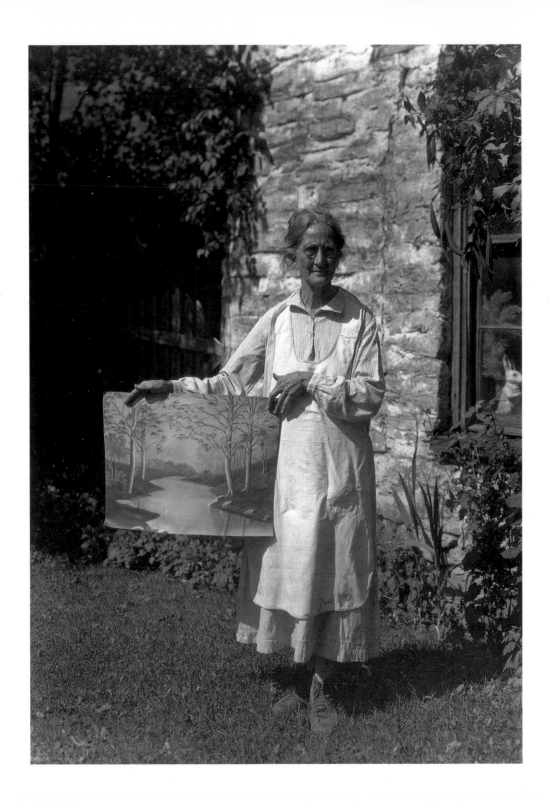

Elizabeth Banes, artist of Long Run, and wife of R. B. Banes. When this photo was taken in September 1932, Mrs. Banes was seventy years of age.

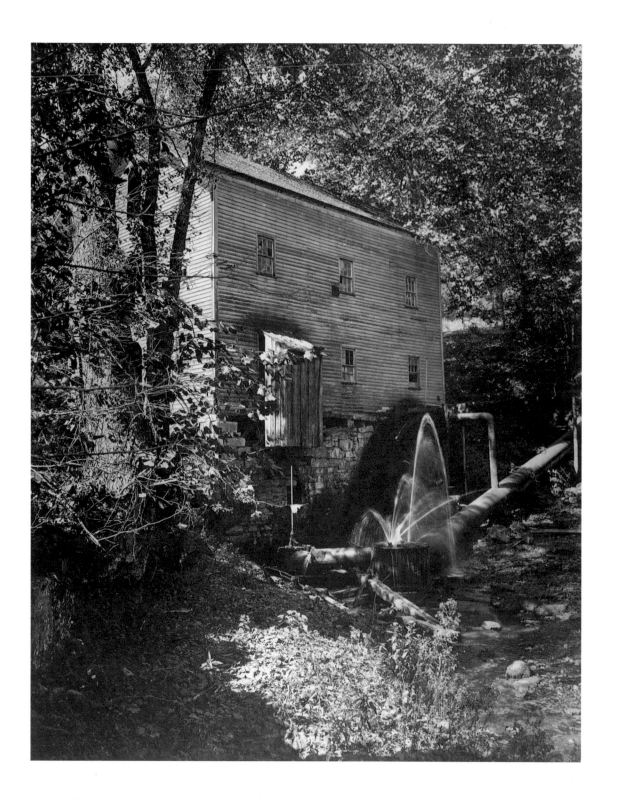

Beck's Mill in the village of the same name in Howard Township, Washington County, about six miles from the county seat, Salem. George Beck built the first structure of logs on the site in 1808. The millstones were quarried from "iron stone" found a short distance from the mill site. Four generations of Becks operated the mill, which closed down about 1938.

The building shown in the photo, a two-story frame structure, dates from 1864. The water which powered the mill came from a nearby cave, and it still flows past the giant water wheel today. The mill was placed on the National Register of Historic Places in 1990.

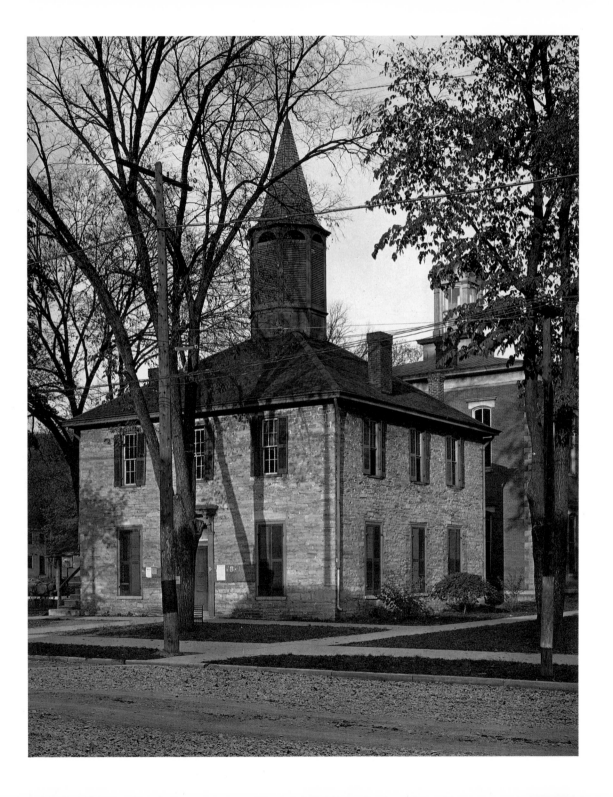

The first state capitol, at Corydon. From statehood in 1816 until 1825, Corydon served as the capital of Indiana. This building was erected as the Harrison County courthouse in 1816, but state government used it until 1825, when Indianapolis was selected as the new state capital. The state purchased the building in 1917. It was restored and was opened as a State Historic Site in 1925.

This photo was taken in August 1931. Saturday was shopping day in Corydon for country folk. Many came in horse-drawn vehicles, which were given priority in parking.

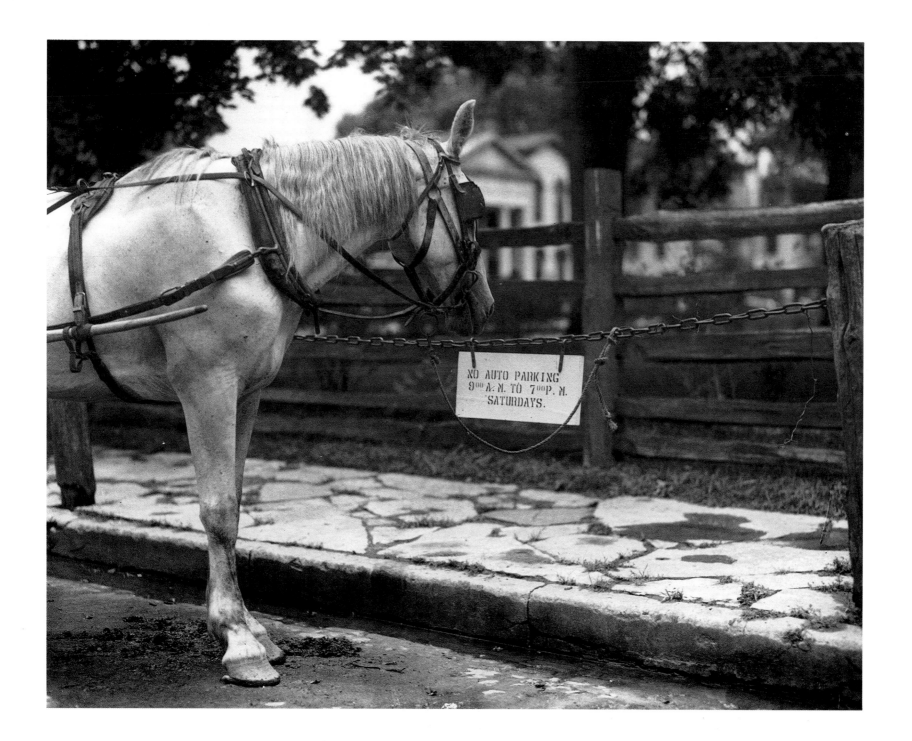

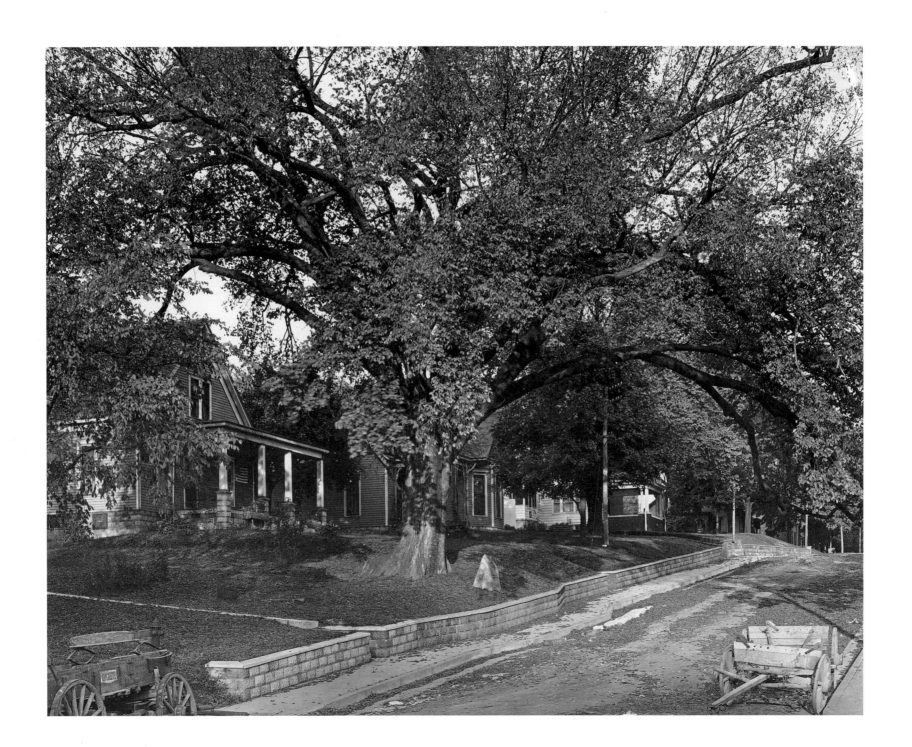

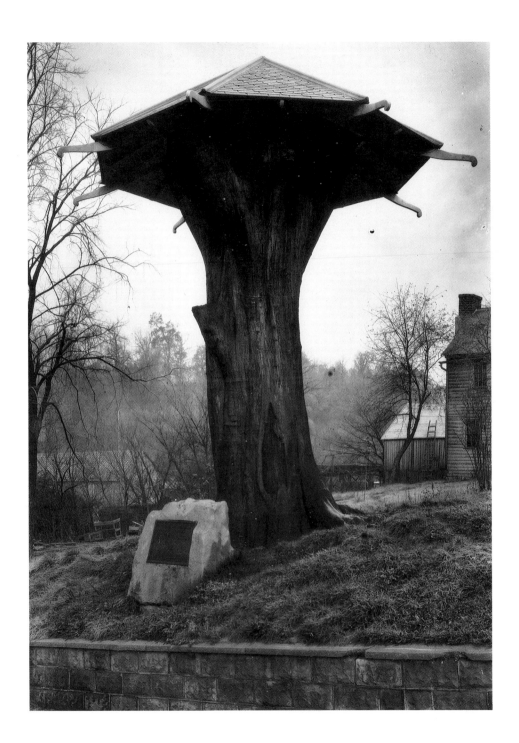

The Constitutional Elm in Corydon. Members of the convention which drafted the state's first constitution at Corydon June 10–29, 1816, sometimes met under the shade of this tree to escape the oppressive heat. The tree, located on what became High Street, suffered an elm blight in 1925, and its limbs were sawn off, leaving several feet of the trunk. This protective wooden canopy was placed over the trunk in 1925. In 1937, a permanent covering of sandstone was erected to protect the stump.

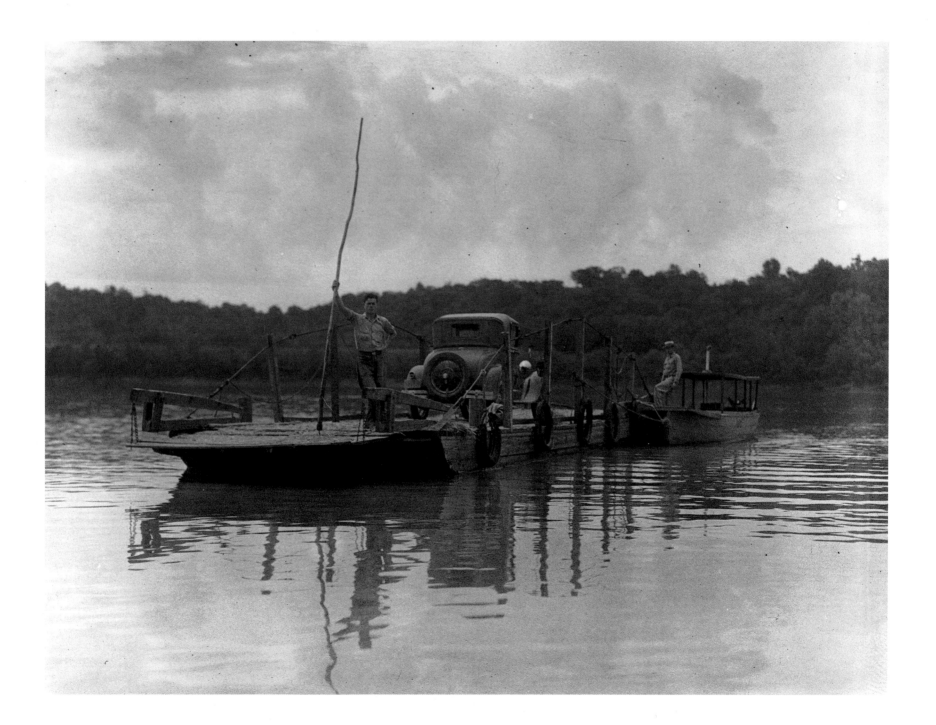

A 1931 photo of the Ohio River ferry which crossed between Brandenburg, Kentucky, and Mauckport, a town in Harrison County, Indiana. The Matthew Welsh Toll Bridge, named for a former Indiana governor, was completed in 1966, simplifying river crossing in this area. On August 24, 1992, three months shy of the 26th anniversary of its opening, the bridge became toll-free.

Mrs. A. H. Ashton, keeper of navigational lights at Tobacco Landing on the Ohio River near Mauckport. Photographed in 1931.

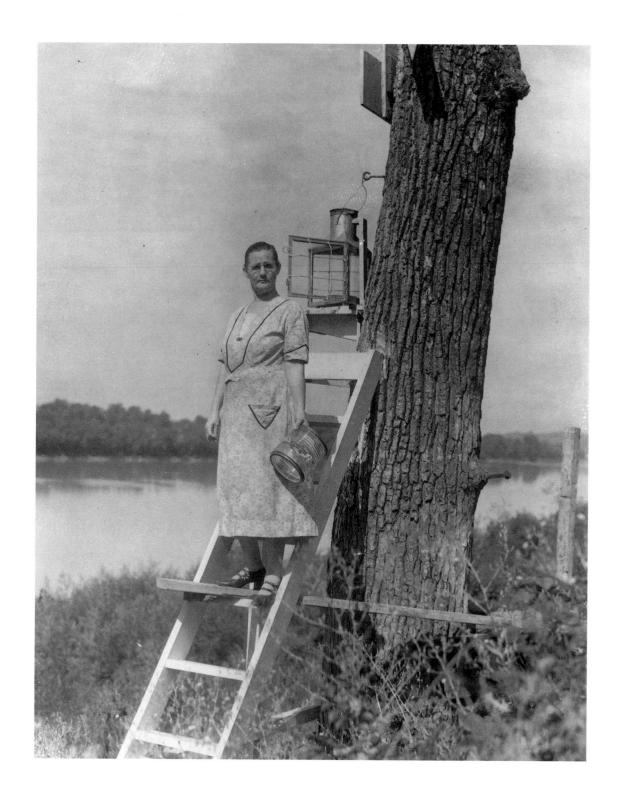

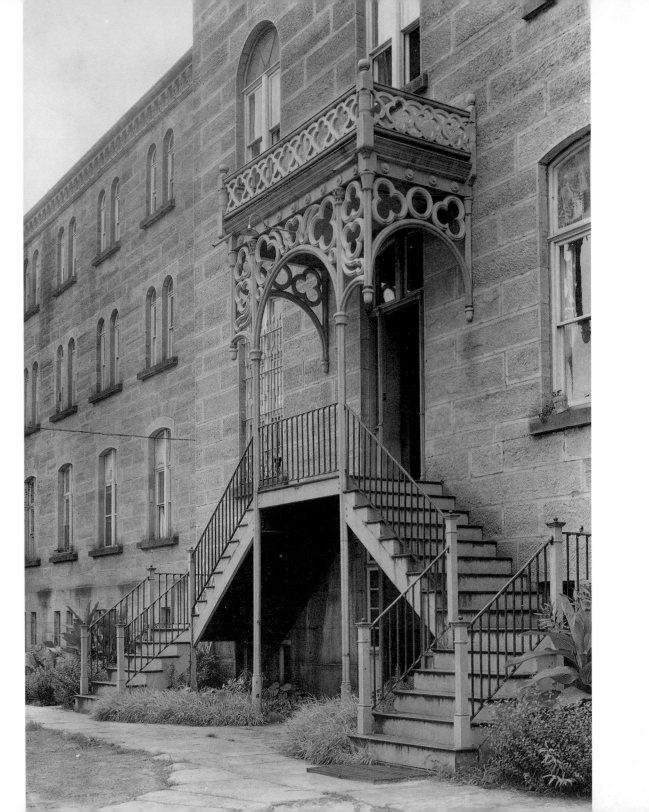

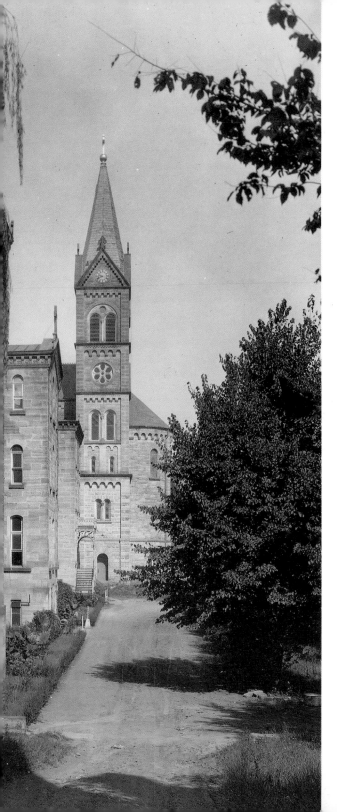

Steps to one of the entrances of the old monastery at Saint Meinrad Archabbey in Spencer County. The steps have been removed since this photo was taken.

Saint Meinrad Archabbey, a Benedictine abbey of the Swiss-American congregation, was founded in 1854 by monks from Einsiedeln in Switzerland. Since its beginning, the monks have ministered to the pastoral needs of parishes in southern Indiana. In 1861, Saint Meinrad committed to preparing candidates for the priesthood. It has grown to become one of the largest Catholic seminaries in the Americas. It was declared an archabbey in 1953, one of two in America.

Beginning in the 1960s, the archabbey admitted women to a summer program in religious education. In 1991 women were admitted to a master's degree program in both theology and religious education that prepares them for work in the parishes.

The monastery, constructed of locally quarried sandstone, burned in 1887. The walls survived, and roofs and new interiors were replaced with new construction. The two photos of Saint Meinrad reproduced here were taken between 1925 and 1931. A "new monastery," also constructed of sandstone, not locally quarried, was constructed in 1982. A new library, partially underground, now serves the students.

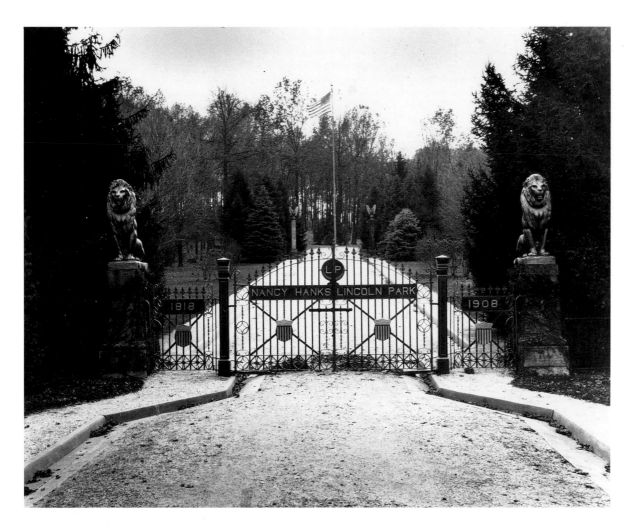

A 1927 photo of the entrance to Nancy Hanks Lincoln Park in Spencer County. Poisoned by milk from cows which had eaten white snakeroot, the mother of Abraham Lincoln died of milk sickness in 1818, two years following the family's move from Kentucky into southern Indiana. She was buried near the Lincoln cabin. The Lincolns moved on to Illinois in 1830, selling the farm. It passed through several owners until public sentiment aroused the state of Indiana to purchase some of the Lincoln farm and memorialize the mother of the sixteenth president with this park near her gravesite.

The state continued land purchases in the immediate vicinity, building the Memorial Building and transforming the area into both a memorial and a state park. In 1962, Indiana relinquished control of the memorial to the National Park Service. It is now called the Lincoln Boyhood National Memorial, consisting of a two-hundred-acre wooded and landscaped park. The memorial incorporated some known parts of the original Lincoln family farm. It contains the "Lincoln Living Historical Farm," a replicated Lincoln cabin, and the gravesite of Nancy Hanks Lincoln.

Adjoining the memorial is Lincoln State Park, containing approximately 1,747 acres with campsites, a lake, picnic areas, and a 1,500-seat covered amphitheater in which the Lincoln Boyhood Drama Association presents *The Young Lincoln* Tuesday through Sunday from June to September.

Very little of the imposing entrance shown in this photo remains. The stone lions flanking the gate were pulled down and, according to some reports, were dumped into a nearby lake. The "Nancy Hanks Lincoln Park" lettering has been removed, as have the dates 1818 and 1908. Two of the shields remain. The eagles beyond the gate have also been removed.

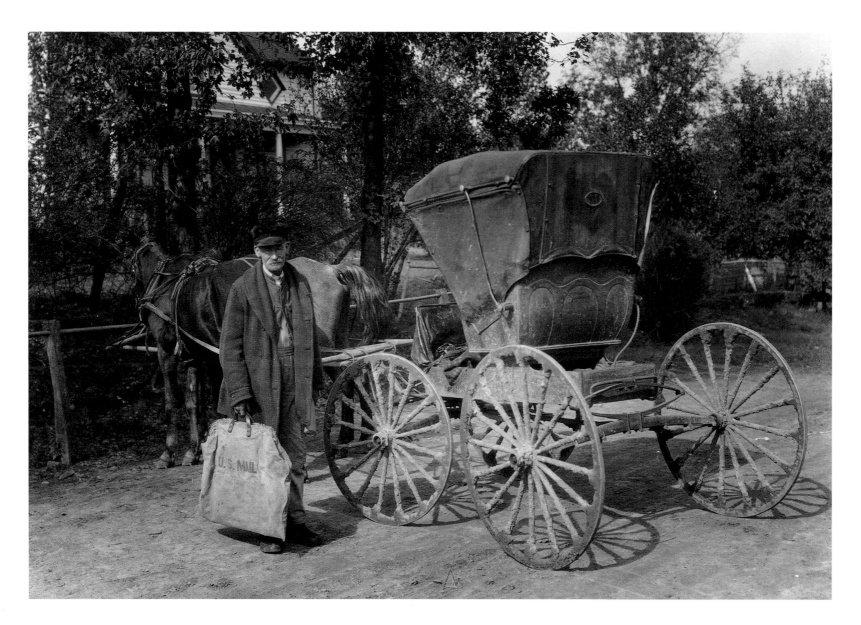

An unidentified mailman in 1925 whose route from the town of Santa Claus was rural Spencer County. Mail delivery was particularly difficult in winter in the twenties before roads were surfaced. In some Indiana counties, the mailman used a horse and buggy in winter and an automobile in good weather. The mud on the spokes of the buggy wheels indicates that this mailman had traveled through a sea of mud on his route.

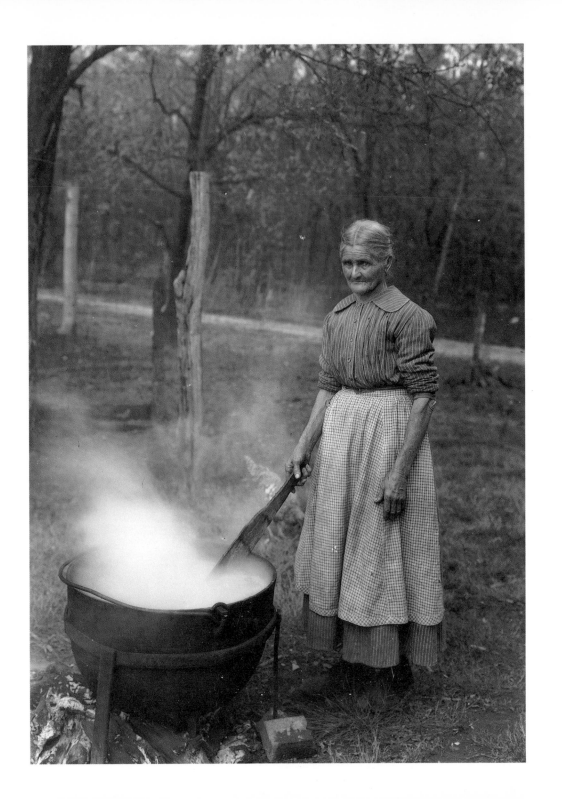

A 1925 photo of an unidentified Spencer County woman making soap the old-fashioned way. Soapmaking was a household art in America long after commercial soapmakers brought their products to the market. Homemakers could save the fat or grease generated from cooking, and mix it with household lye to produce an acceptable soap.

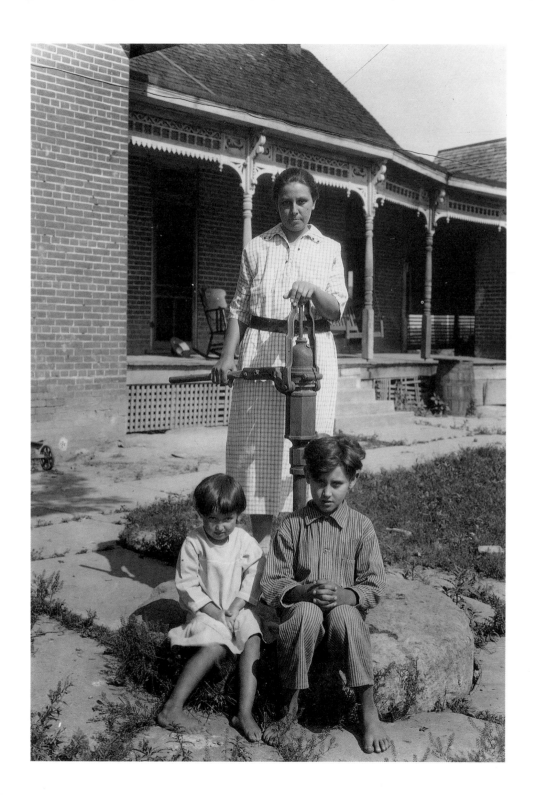

Mrs. Thomas E. Martin and her children, Doris Emeline and Terrell Grant, photographed at their home near Wheatland, Knox County, in 1925. Mrs. Martin was Ruth Williams, great-granddaughter of James D. (Blue Jeans) Williams, who served as governor of Indiana 1877–1880. The house in the background was built on the site of Governor Williams's original home.

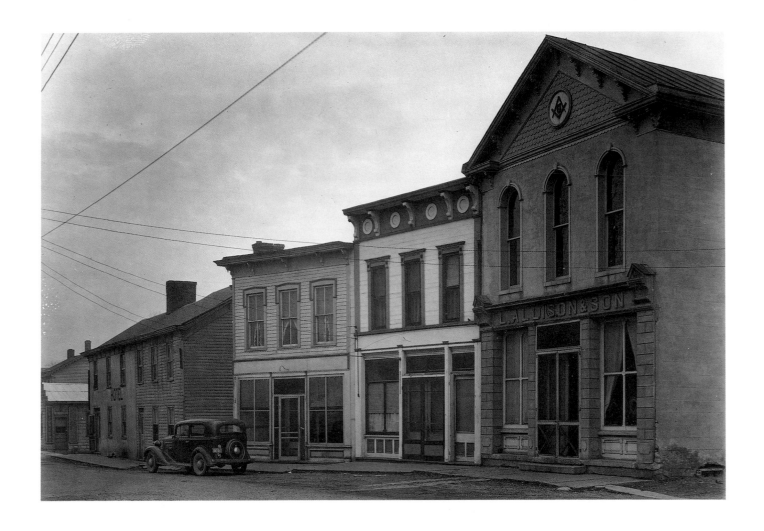

Street scene in Metamora in 1941. When this photo was taken, this Whitewater Canal town had not yet awakened from its decline following its boom days in the 1840s and '50s. The establishment of the Whitewater Canal State Historic Site by the Indiana General Assembly in 1946 led to a rejuvenation of the town. Today it is a prime tourist spot in the state and a splendid example of a renovated and restored canal town of the 1840s.

The building on the right, Odd Fellows Hall, was erected in 1853. It has served many purposes, including a town hall, post office, and general store operated by L. Allison and Son.

The Whitewater Canal was authorized by the Indiana Internal Improvement Act of 1836 When finally completed by a private company in 1847, it extended from Hagerstown to the Ohio River at Lawrenceburg. It served the Whitewater Valley counties well, for the principal market for agricultural and other products from this area was Cincinnati. Shipment by water was both cheap and expeditious. Existing towns along the waterway, particularly Connersville, Laurel, Metamora, and Brookville, profited greatly from the canal. It was viable for a short period before railroads put it out of business. In 1864–65 the canal was sold to a company which constructed a railroad along the towpath. Portions of the canal, however, continued to serve for decades as a source of power for gristmills and for the generation of hydroelectric power.

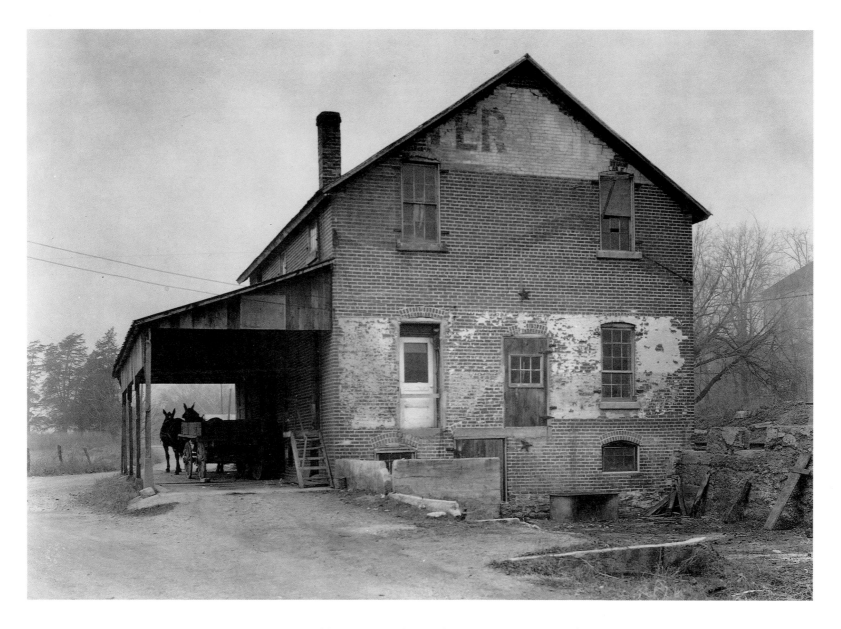

The old water-powered gristmill located at the west end of Metamora by the canal lock. The mill has a long history. The first mill on this site was built in 1845 by Johnson Banes, some two years after the Whitewater Canal was completed from Brookville to Laurel. The mill was destroyed by fire in 1856 but was rebuilt in 1857. It was renovated in 1900 and again in the 1930s. Today it is a functioning mill and attracts many tourists, especially when the giant water wheel is in motion.

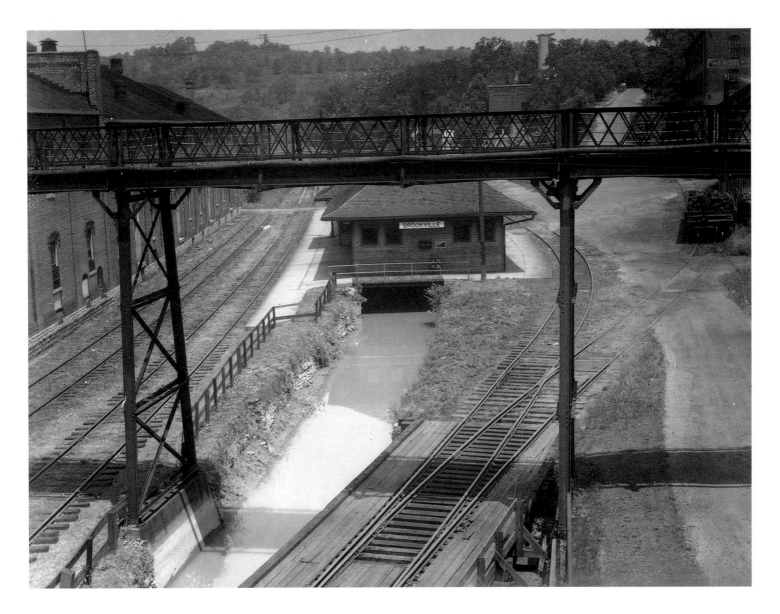

A 1941 photo of the railroad depot at Brookville, built over the Whitewater Canal. The first railroad to serve Brookville was the Cleveland, Chicago, Cincinnati, and St. Louis, the Big Four. It was completed through Brookville in 1866, partially constructed on the towpath of the Whitewater Canal.

After this photo was taken, the depot was sold, and the owner moved it to a site near Metamora. The canal was filled in, and the area is now occupied by a fiberglass factory.

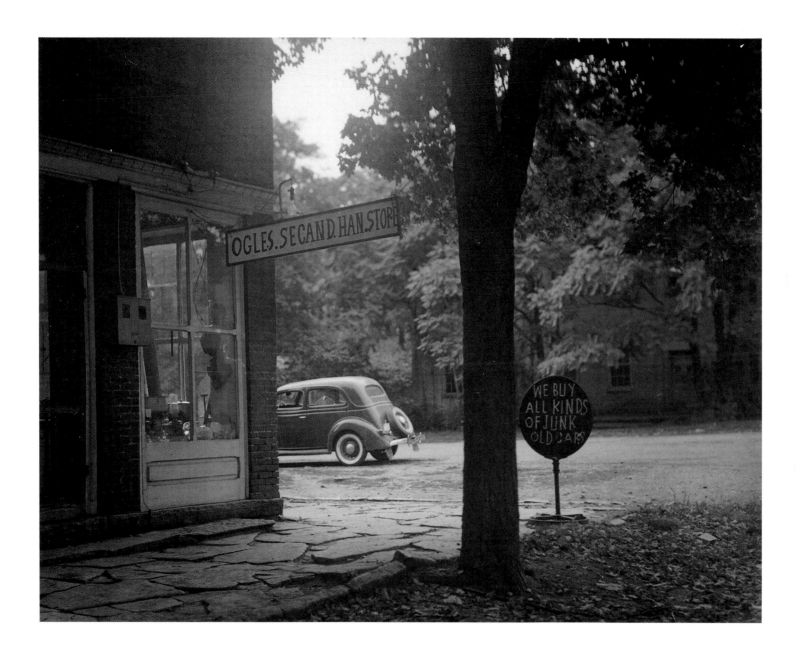

It may never be known if this business sign in Laurel, a village in Franklin County, was contrived or the result of a spelling deficiency on the part of the Ogles. Hohenberger thought it interesting enough to photograph in 1941.

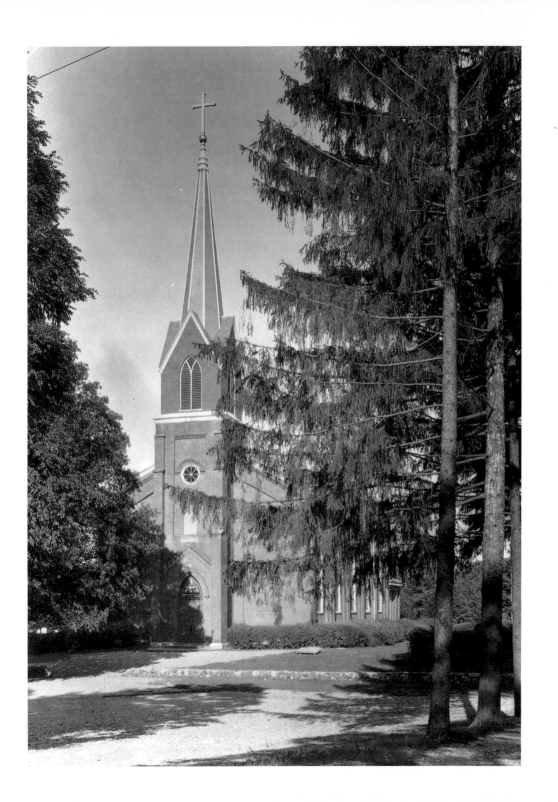

St. Mary's of the Rock Church in 1941. It is located in Butler Township, Franklin County, in the village of Haymond, generally called St. Mary's by contemporary residents. Historically this Catholic church dates from 1844, when a log church was erected on the site to serve the farmers of German extraction in the community. The present building dates from 1906.

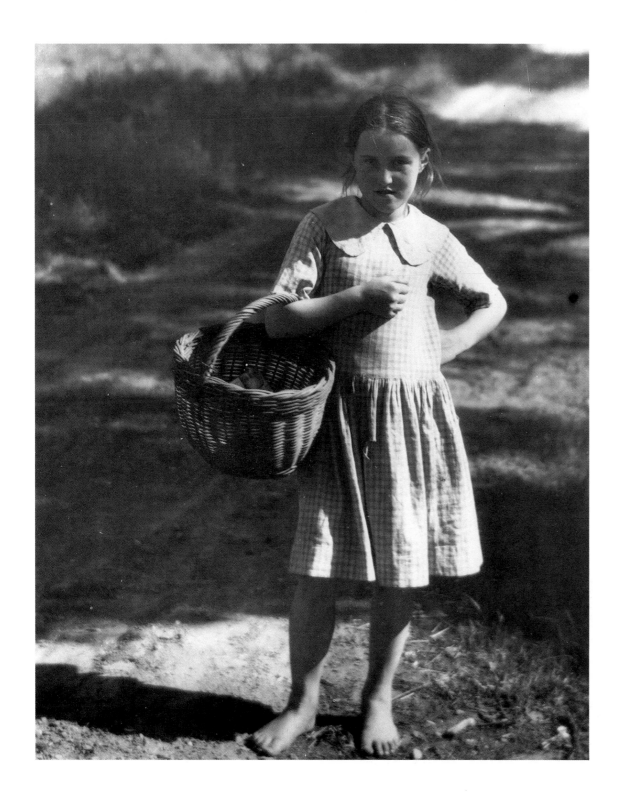

Myrtle (Irene?) Bohall, daughter of John Bohall, the eastern Monroe County basketmaker, in a 1929 photograph.

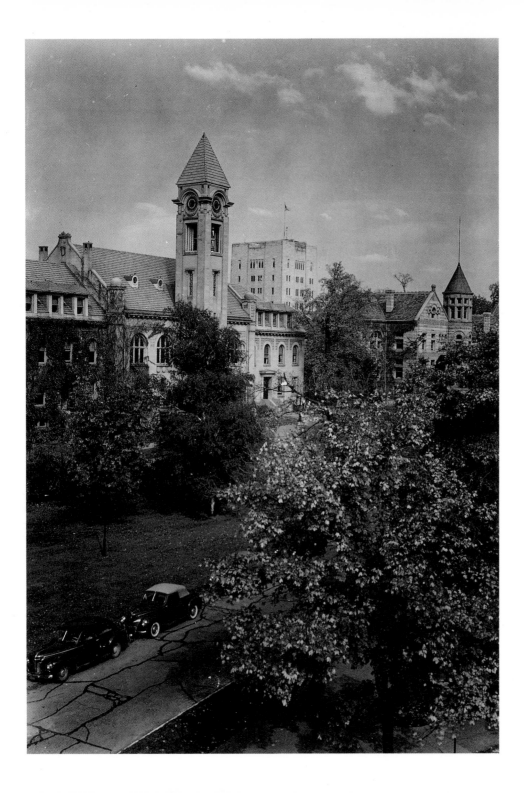

The Student Building at Indiana University, Bloomington, in 1944. Photographed from the president's office on the second floor of Bryan Hall. To the right is Maxwell Hall, with the tower of the Memorial Union Building in the background.

Harry Engle and his Bloomington art class in Brown County about 1931. Engle was a professor of Fine Arts at Indiana University, Bloomington, from 1928 to 1969, and periodically took his adult art class to Brown County to paint pastoral scenes. From left to right the students were Mrs. Alice Regester, Mrs. Monta Martindale, Helen Smitz, and Mabel Ross.

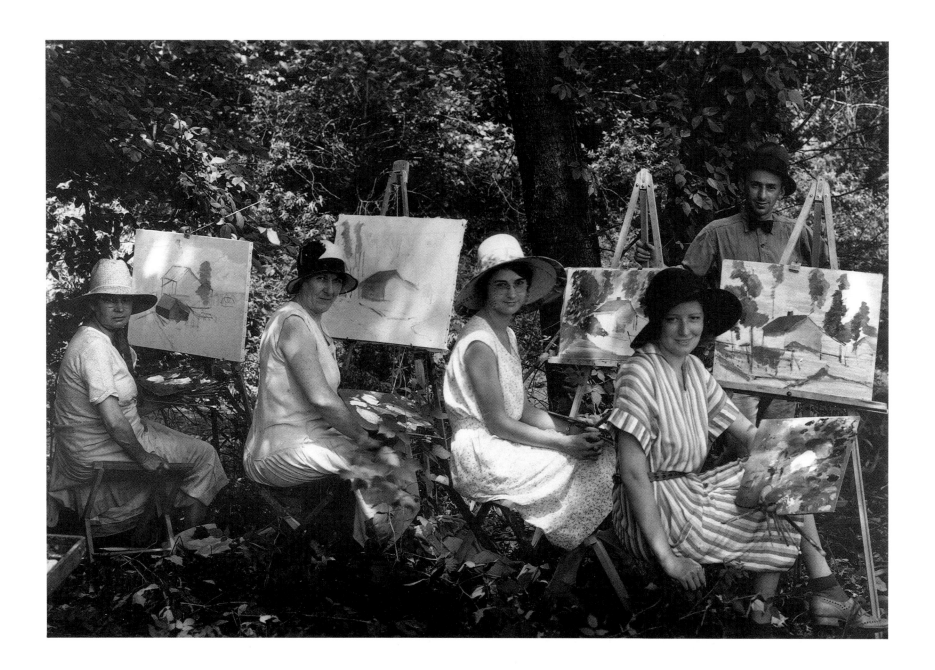

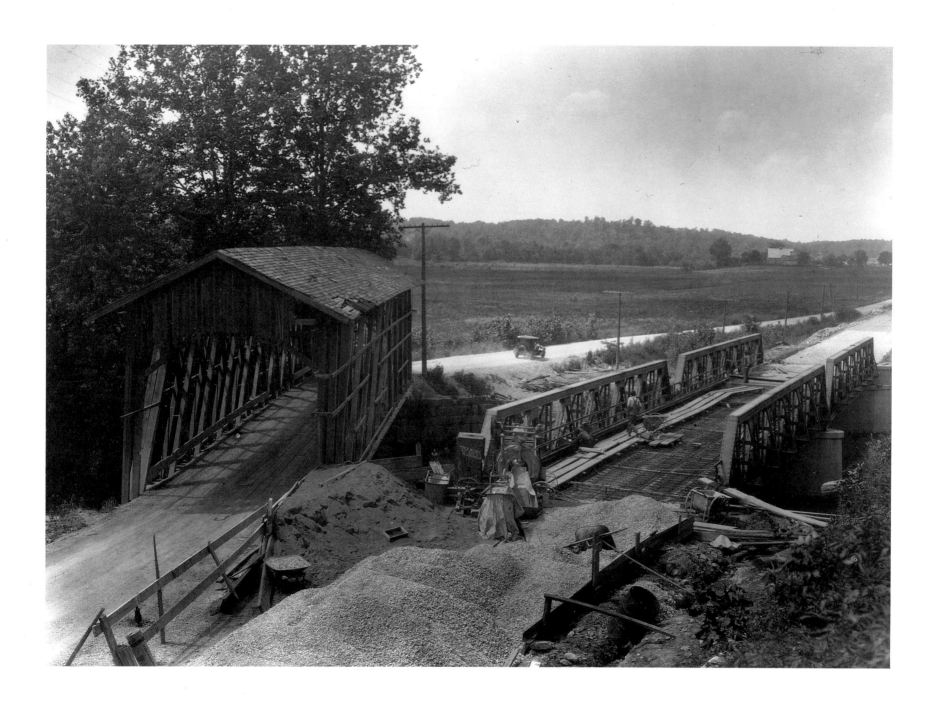

The old covered bridge over Bean Blossom Creek at Dolan, north of Bloomington, being replaced in June 1927.

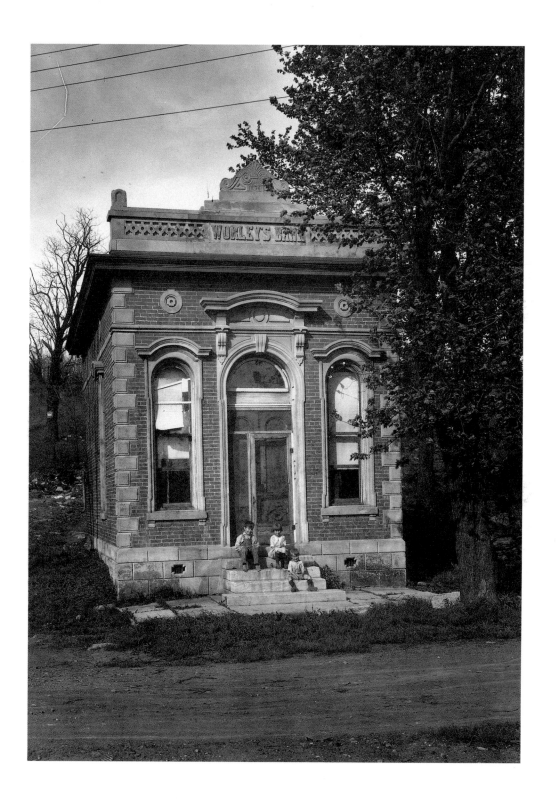

The Worley bank building in Ellettsville in 1927. F. E. Worley, a farmer and dealer in livestock, began his banking business in 1873. In 1874, he built this building to house his business. When this photo was taken, the building was being used as a home. It has since been razed.

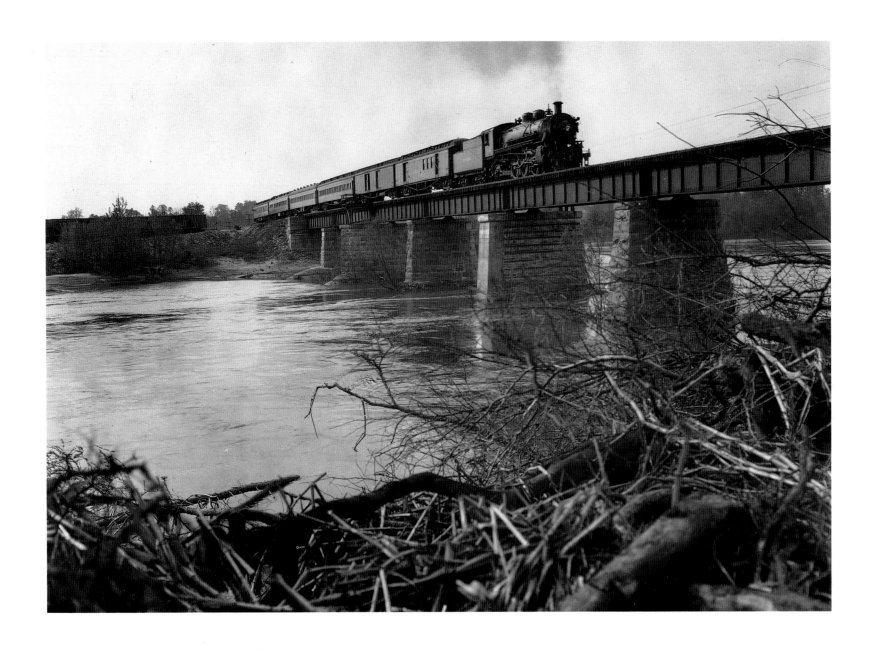

A 1927 photo of the Monon railway bridge over the West Fork of the
White River near Gosport in Owen County.

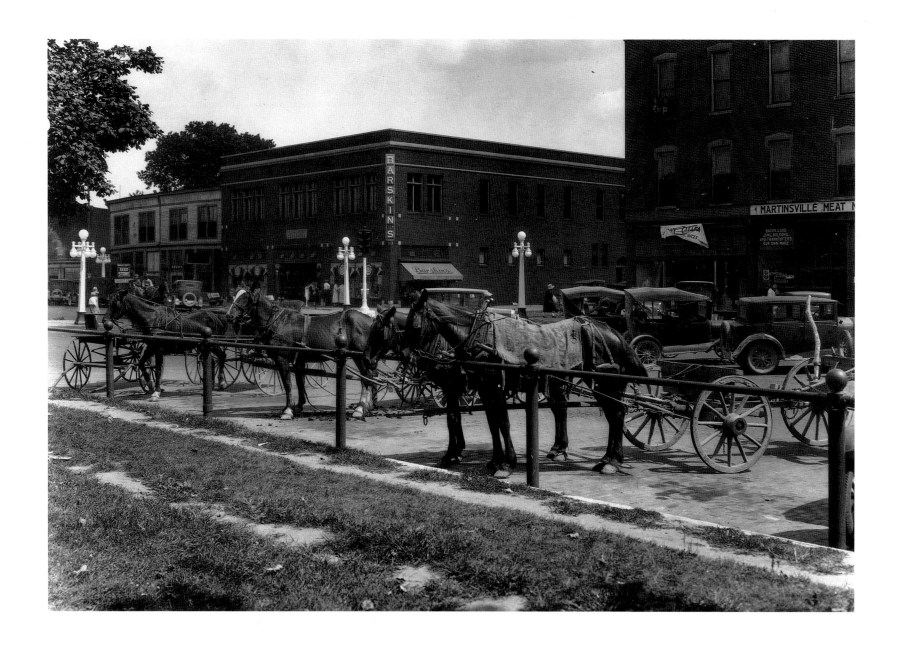

In 1927 horses and automobiles shared the parking facilities in the
town square at Martinsville.

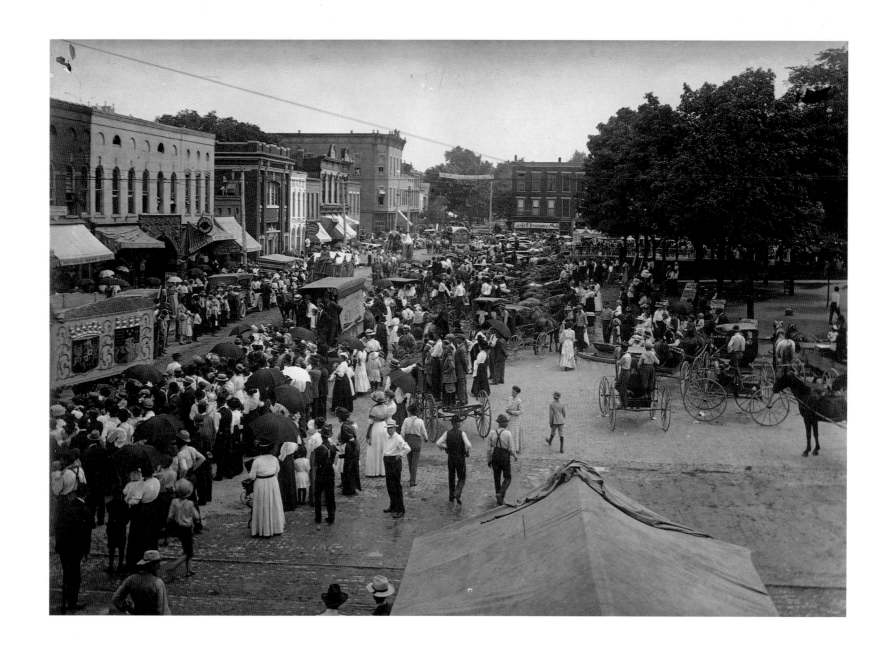

Circus day at Martinsville about 1927, with the pre-performance parade going through the town.

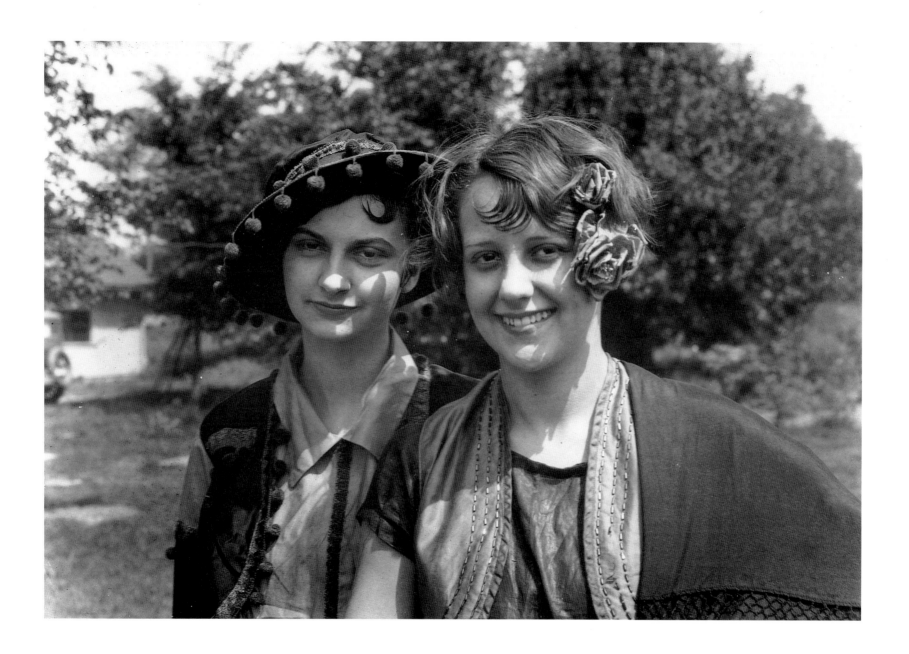

Two youthful dancers of Martinsville, Marian Gravis and Miss
Terhune, photographed in 1928.

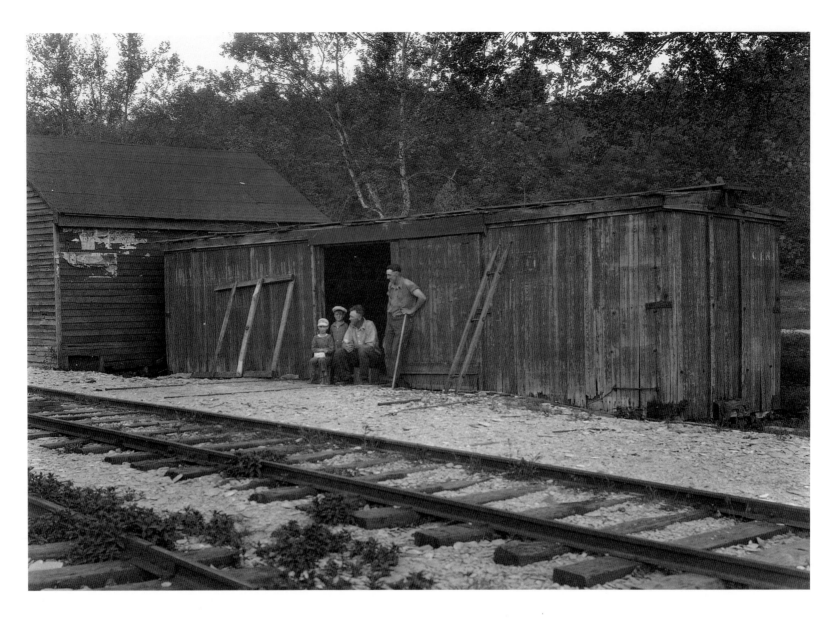

Railroad workers and their young friends at the Avoca stop on the Bedford-Bloomfield branch of the Monon Railroad in 1928. Monon acquired the narrow-gauge railway called the Bedford, Springville, Owensburg, and Bloomfield Railroad in 1886. The gauge was standardized in 1895. "Old Nellie," as the line was affectionately called, made a round trip daily for passengers between Bedford and Switz City. Periodic cave-ins of the long tunnel at Owensburg caused traffic disruptions. Passenger traffic on the B & B was discontinued in 1927. In 1935 a mammoth cave-in at the tunnel caused freight traffic to cease. The road bed was dismantled, and the rails were sold as scrap to a steel company.

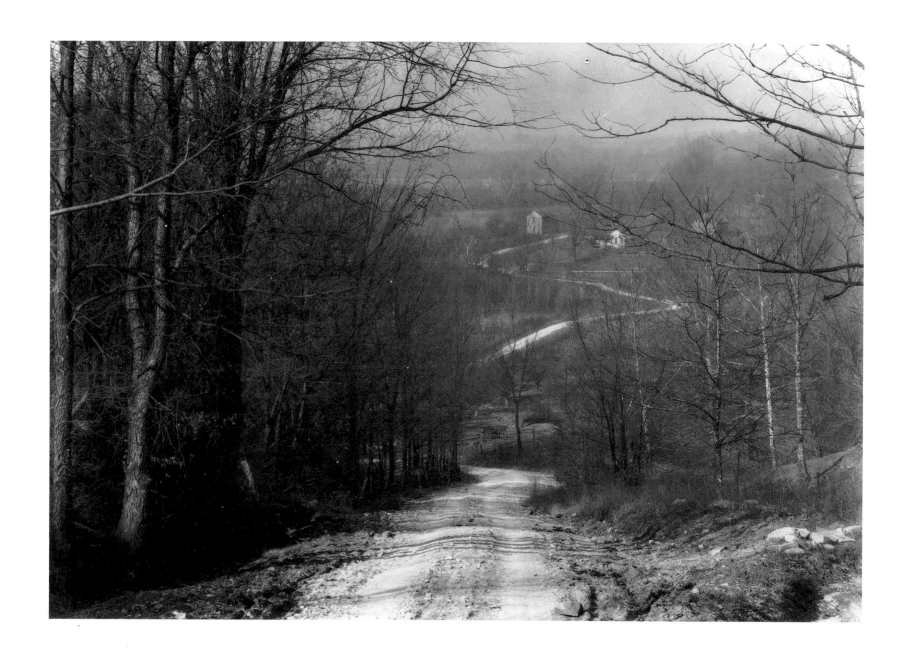

Mount Tabor Hill near Stinesville in Monroe County. This photo was taken in 1927.

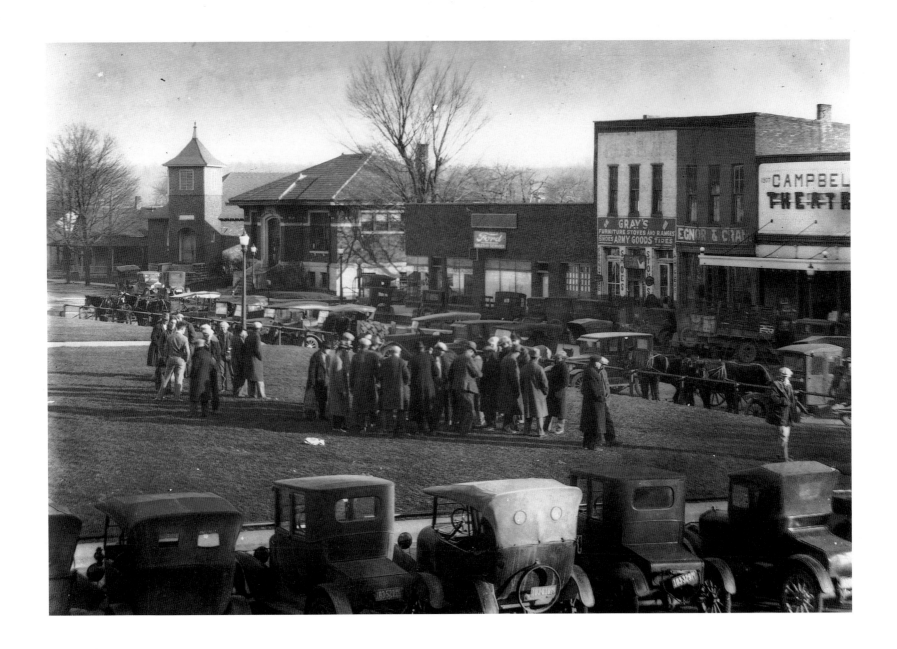

The fur market at Spencer in 1927. For more than a century, on Saturdays from November through February, trappers from throughout the Midwest have brought their pelts to the courthouse square in Spencer to sell or barter.

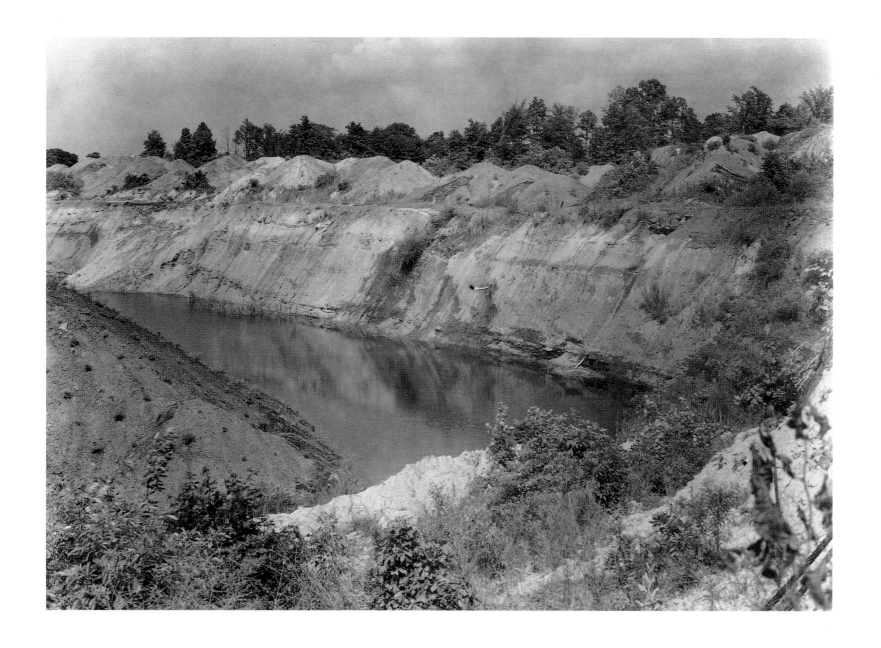

A 1946 photo from Clay County, between the villages of Ashboro and Bowling
Green. The disfigured land is the result of strip mining for coal.

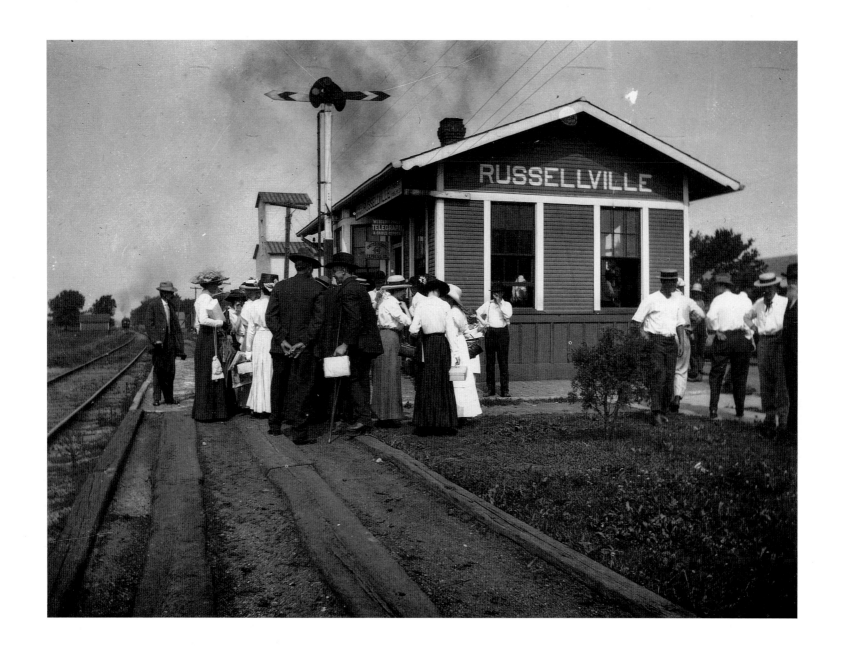

An undated photo of the railroad station at Russellville in Putnam County.

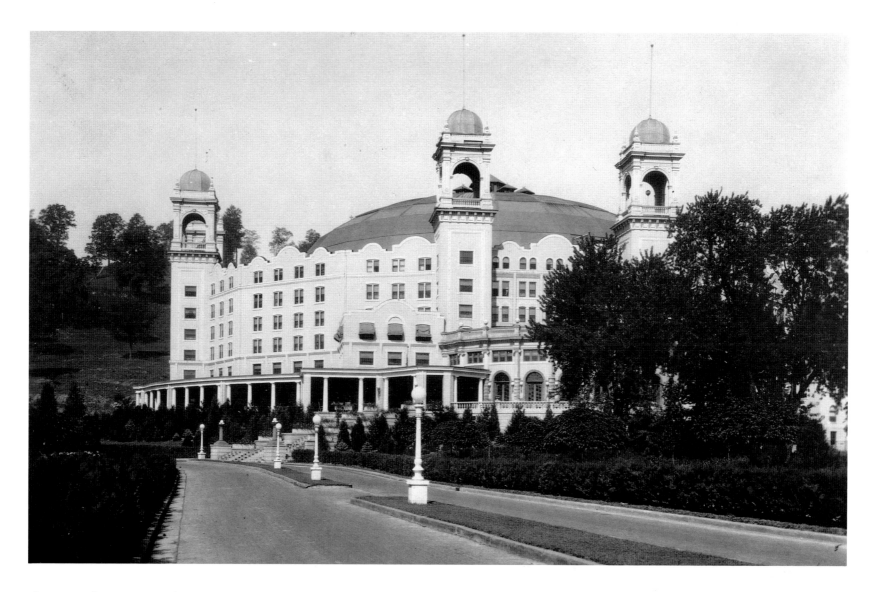

The West Baden Springs Hotel, at West Baden Springs in Orange County. Once advertised as the "Carlsbad of America" and called the "eighth wonder of the world," for almost three decades the hotel was the playhouse of the rich, the famous, and the notorious. Designed by Harrison Albright, the hotel is said to feature the third-largest unsupported dome in the world. The interior is a perfect circle, with rooms overlooking the vast court. Another circle of rooms face the outdoors. The hotel was constructed by the firm of Caldwell and Drake of Columbus, Indiana, which employed 516 men and completed the construction in 337 days in 1902. From that date until 1931, except for the World War I years, when it served as a hospital, guests came to drink the mineral water, ride, play golf, gamble, eat, and watch circus performances in the court under the dome. The Depression brought an end to the glorious days, and the hotel closed in 1931. Thereafter it was used as a seminary by the Society of Jesus, and as a college by the Northwood Institute. Since 1983 the building has gone unused, and it is now deserted, falling into ruins.

Many have tried to save the historic landmark. In 1991, the West Baden Springs Hotel Development Coalition was formed to raise funds to preserve the building. The coalition cause was given encouragement in 1992 when the National Trust for Historic Preservation placed the hotel on its list of "America's 11 Most Endangered Historic Places."

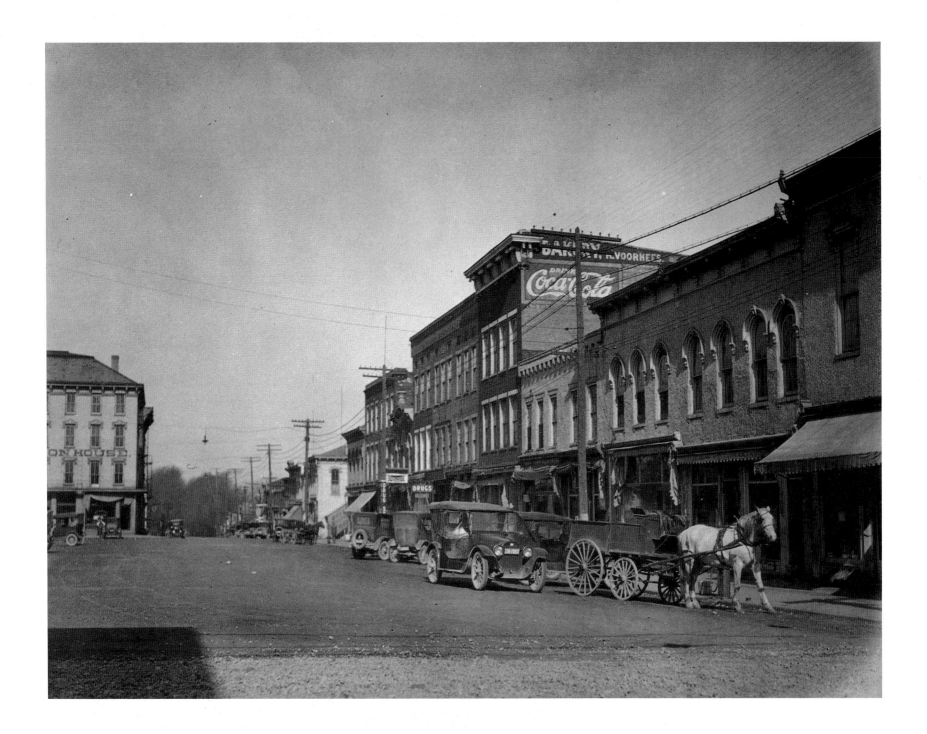

Street scene in Liberty, county seat of Union County, in 1926. All the buildings on the right are still standing, but some of the fronts have been modified. The building on the left was a hotel known as the Corrington House. It was razed, and the site is now occupied by a convenience store.

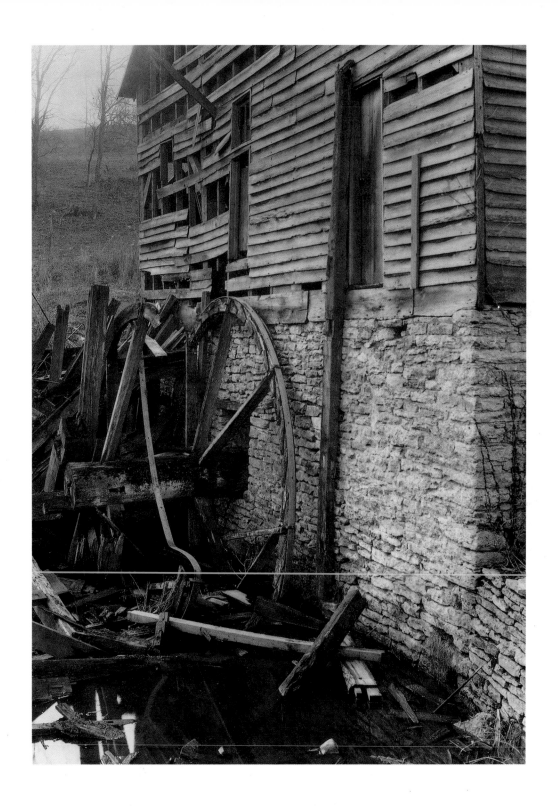

This photo shows all that remained in 1925 of Seer's gristmill on Simpson Creek near Brownsville, a village in Union County.

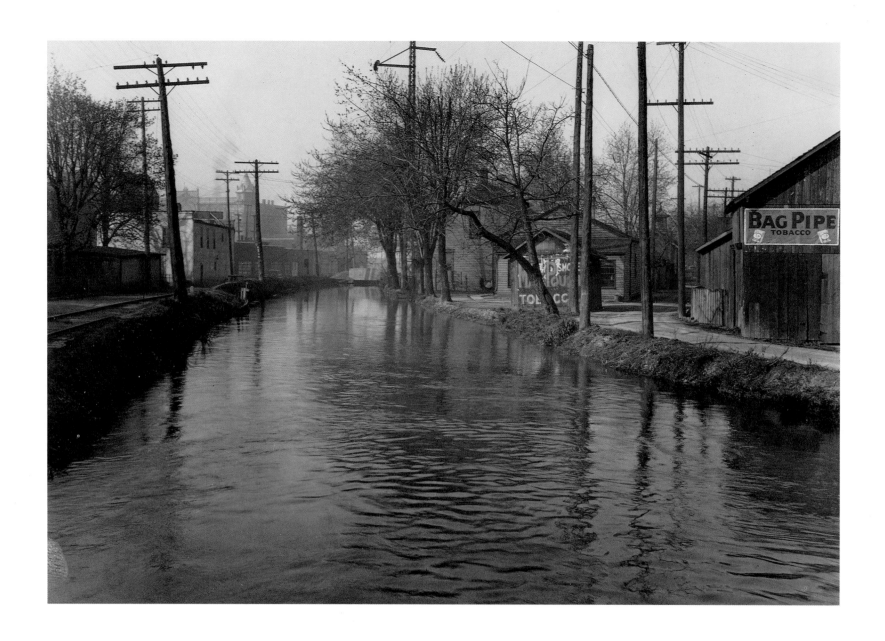

A view of the Whitewater Canal as it appeared in 1925, flowing through Connersville. This part of the canal has been filled in and is now a part of Western Avenue.

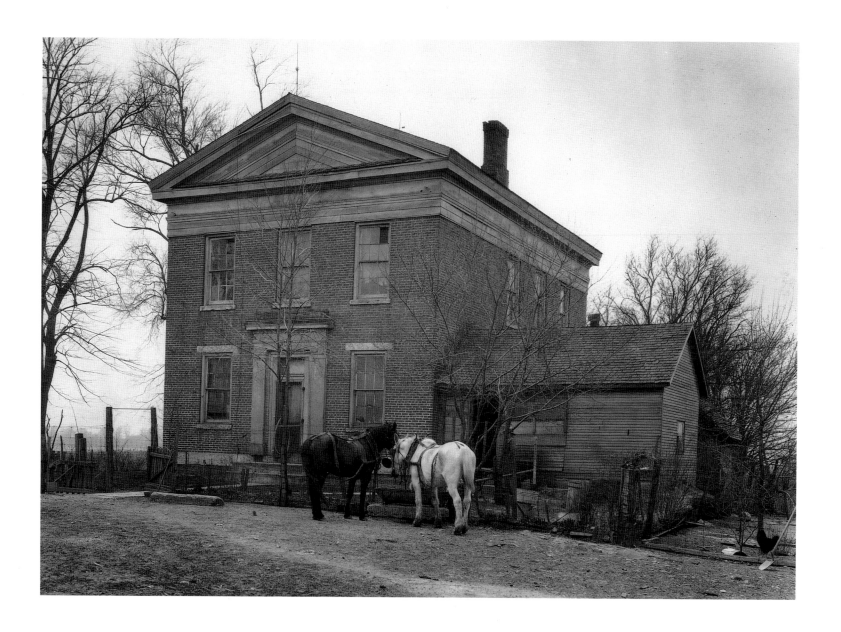

A 1925 photo of the building which housed Fairview Academy. Located near Fairview in Rush County, the academy was incorporated in 1848, moving into this building in 1849. It was financed by public subscription, mostly by members of the Christian Church. It is written that the school drew students not only from Indiana but from neighboring states as well. The academy advertised that it was open to both sexes. It prospered for several decades but waned when public high schools were opened. The building was sold in the 1870s, and the proceeds from the sale were turned over to the Rush County school fund.

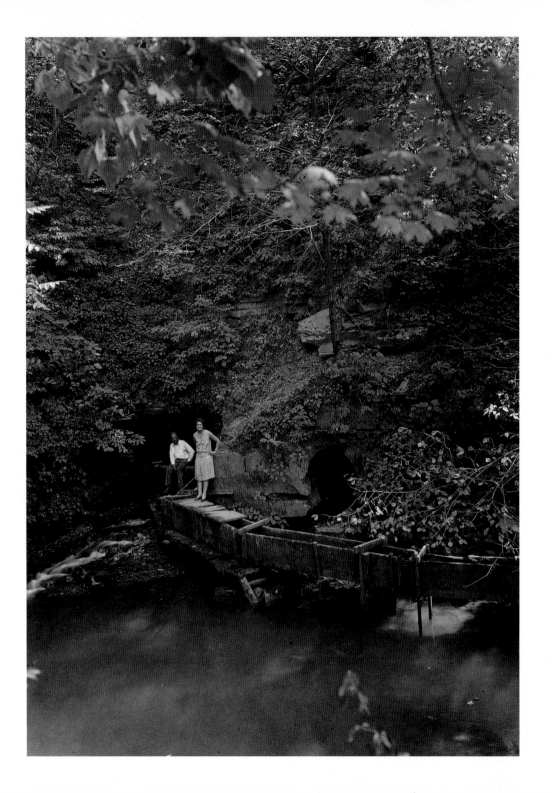

Hamer Cave in the pioneer village of Spring Mill, in the state park of the same name. The cave is named for the brothers Hugh and Tom Hamer, who owned the village for several years. The great stream of water from this cave powers the restored gristmill and sawmill as it did in the pioneer days.

Through the efforts of many local people, the area was converted into a state park in 1928, and the work of restoration on the pioneer village and the mill began. This photo was taken in 1929. Today, Spring Mill State Park, located near Mitchell, is one of the most delightful parks in the state, offering visitors a variety of outdoor activities.

The long flume carrying the water from Hamer Cave to the giant wheel which powers the gristmill and sawmill in the pioneer village at Spring Mill State Park. Photo 1936. This three-story gristmill was constructed in 1817 by the proprietors of Spring Mill, Thomas and Cuthbert Bullitt. The limestone was quarried from the surrounding hillsides. The mill operated in this Lawrence County village until about 1892.

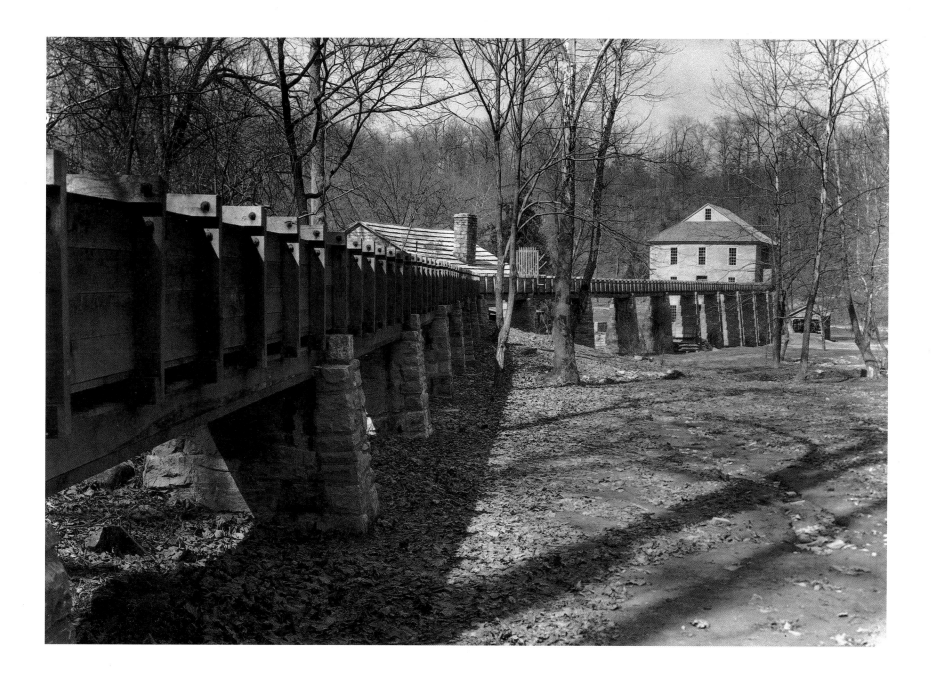

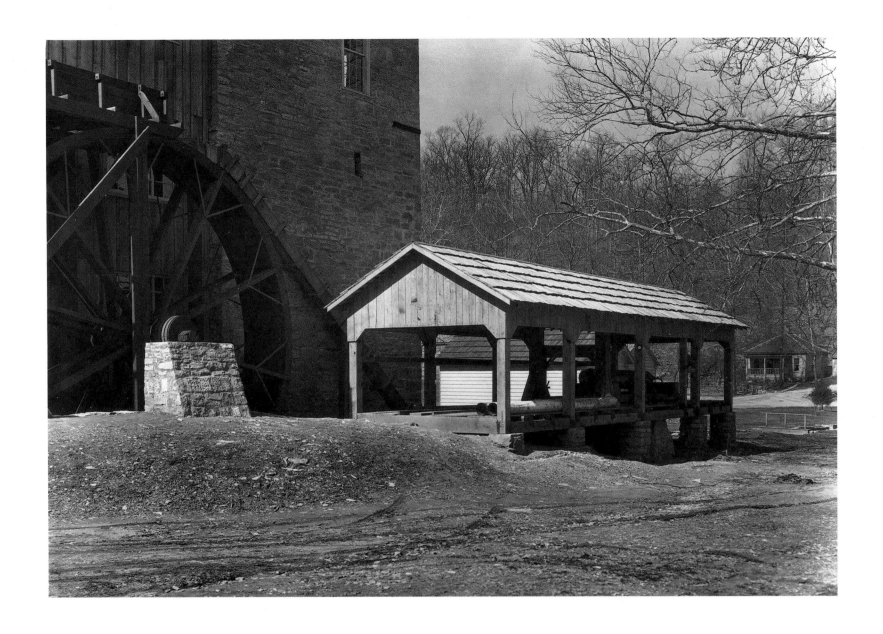

A 1932 photo of the giant water wheel which powers the gristmill and the sawmill (*at right*) in the village of Spring Mill.

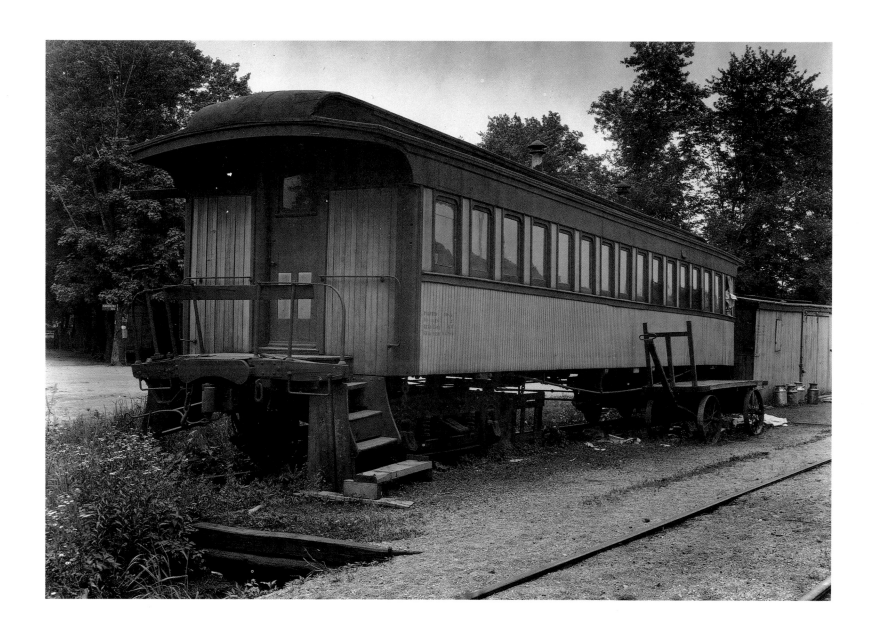

This railway car served as the Big Four railroad
station at Boggstown, in Shelby County, in 1927.

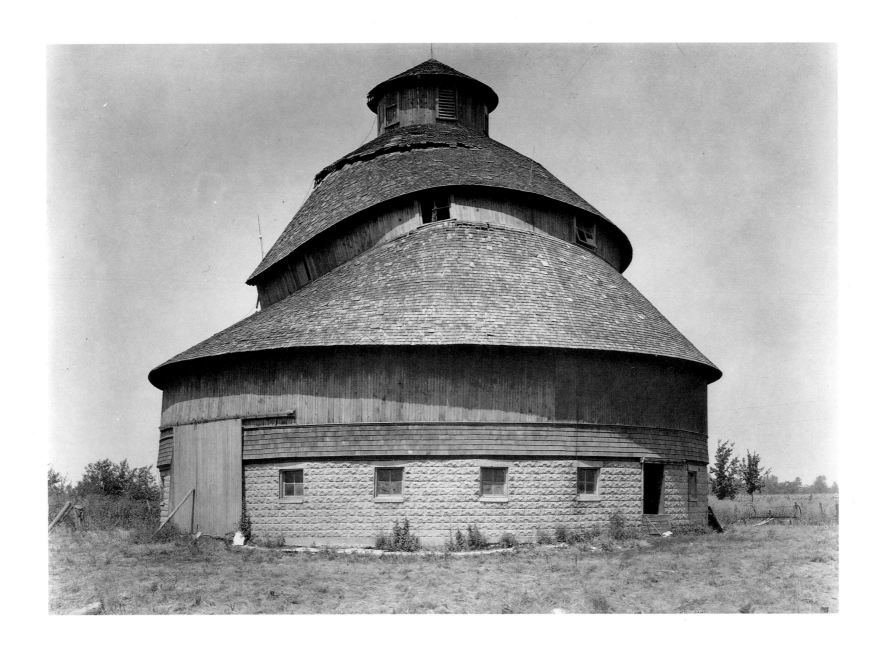

This unusual round red barn could be observed some six
miles east of Columbus in 1941.

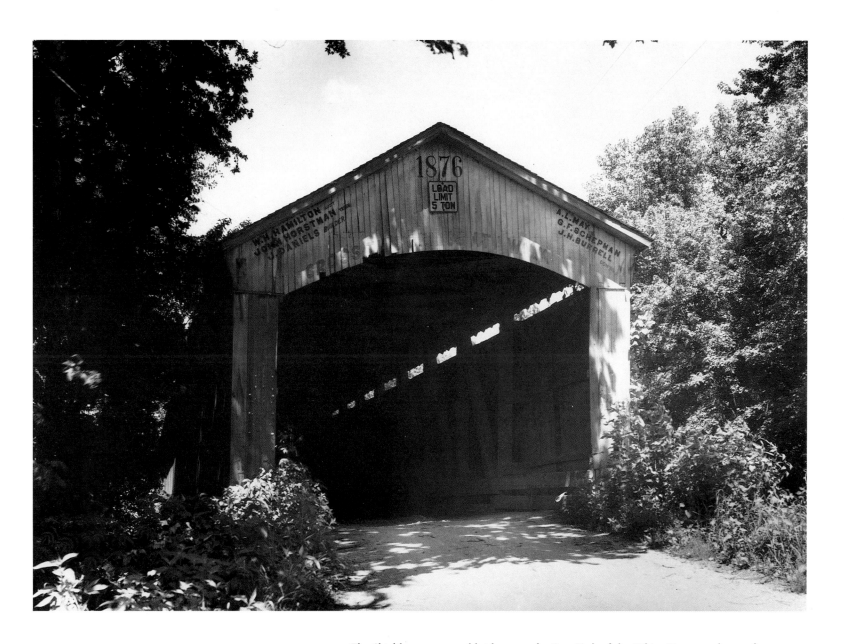

The Shieldstown covered bridge over the East Fork of the White River, northeast of Brownstown in Jackson County. The bridge was built by Joseph J. Daniels of Rockville in 1876. Daniels was the most active builder in Indiana. It has been estimated that he built approximately sixty bridges throughout the state. The photo dates from 1946.

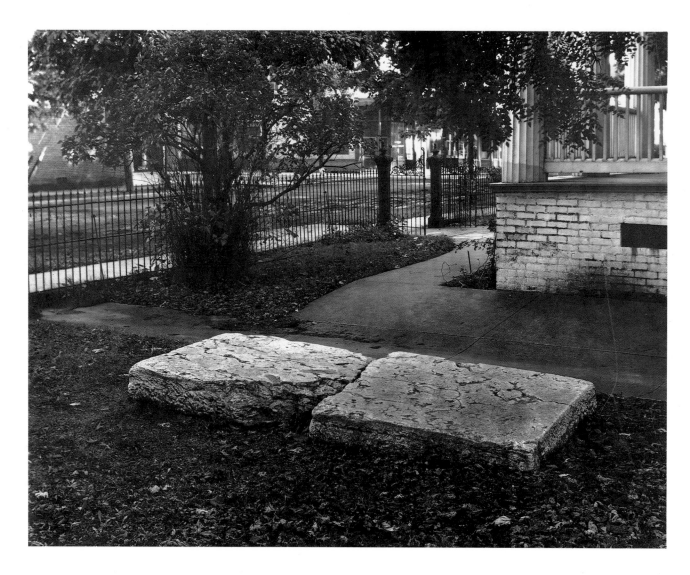

The footprints of the Angel Gabriel? Many members of the Harmony Society who settled the present town of New Harmony in Posey County thought so. This limestone slab, containing the outline of feet, was photographed in the backyard of the former home of George Rapp, spiritual leader of the Harmonists.

The Harmony Society, whose members were sometimes called Rappites after founder George Rapp, was a successful communal society which moved from its first settlement at Harmony, Pennsylvania, and founded Harmony in Posey County, Indiana. During the Indiana sojourn, 1815–1825, the society built many permanent, attractive, and spacious buildings at Harmony, which today represent a major attraction for tourists. In 1825, the society sold all its land and improvements to Scottish philanthropist Robert Owen for his utopian experiment. The town was renamed New Harmony, and it attracted intellectuals from Europe and the eastern United States. In 1827 Owen dissolved the community, but many of the participants remained, and some of their descendants live in the town today.

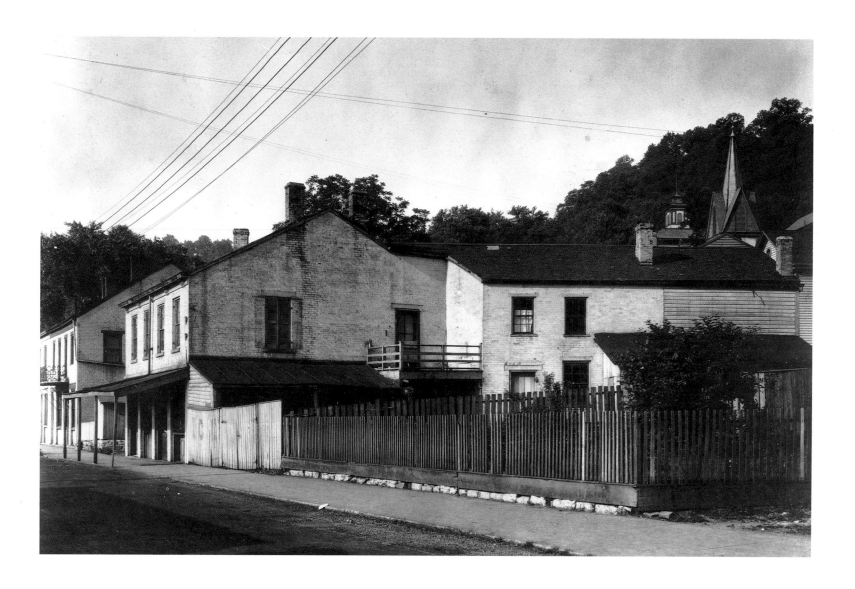

Street scene in the Ohio River town of Aurora, Dearborn County, in 1928. To the right may be seen the steeples of the First Presbyterian Church, built in 1850, and of St. Mary's, erected in 1864.

The town was founded in 1819 and was named for the goddess of dawn by Jesse Lynch Holman, one of the founders. When the Ohio River was the main artery for commerce, Aurora was a bustling trade center. Today life is calmer in this town of charming old homes overlooking the river. Civic pride is high, and many of the old homes and buildings are well preserved.

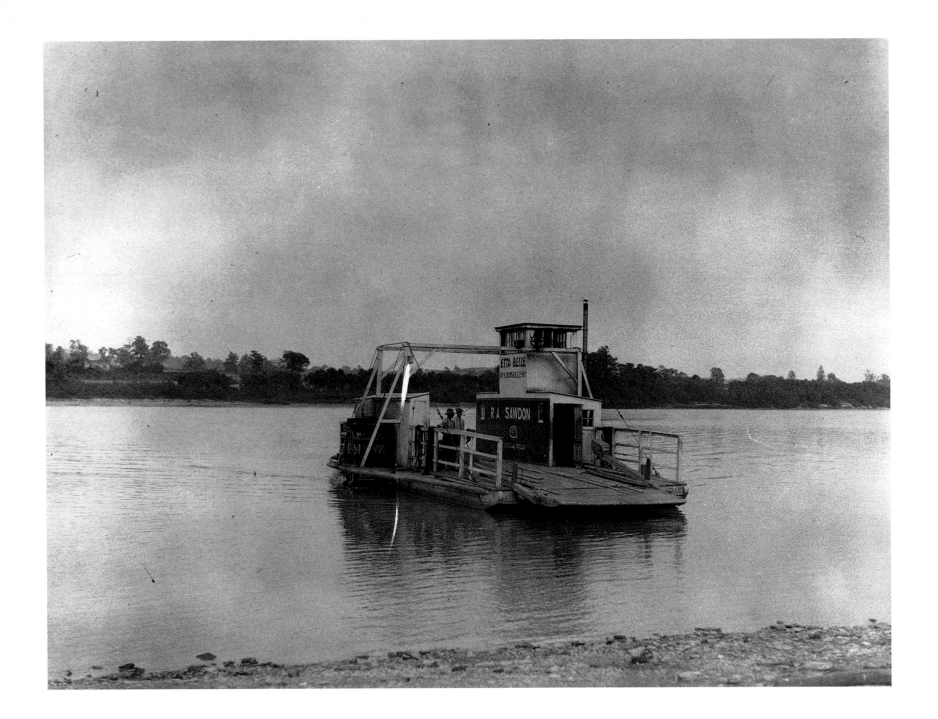

A 1926 view of the ferryboat operating between Aurora, Indiana, and Petersburg, Kentucky. The Ohio River bridge at Lawrenceburg, built as part of Interstate 275, put an end to the ferry business.

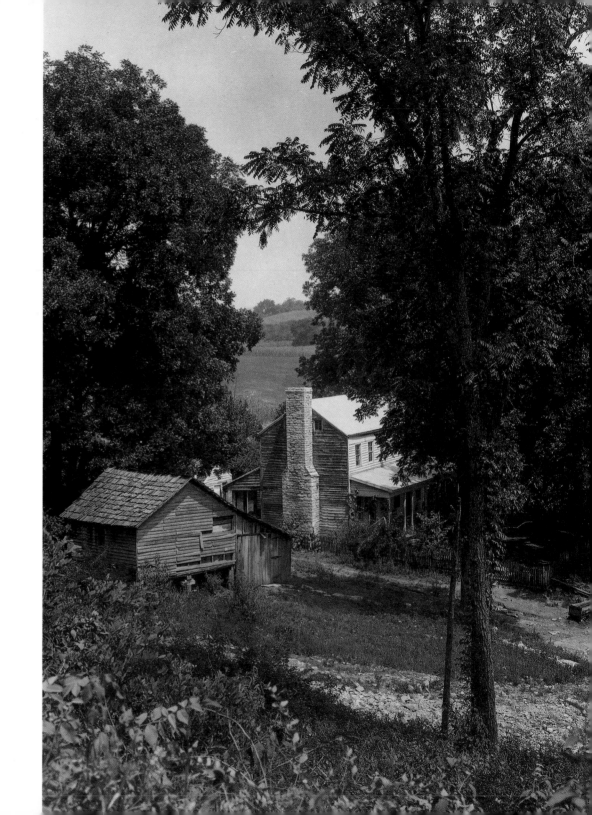

Landscape near Wyandotte Caves in Crawford County, 1928.

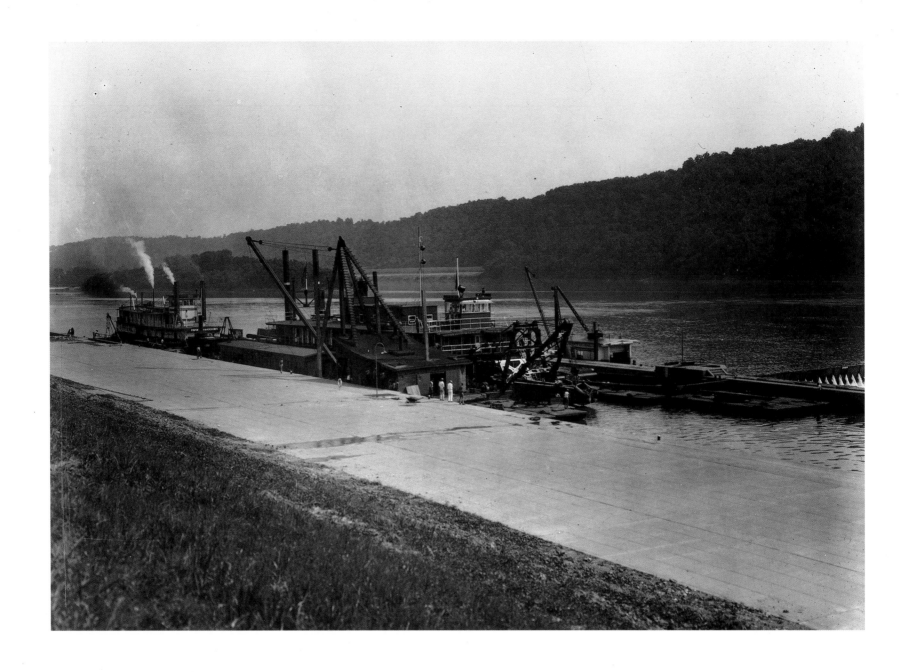

A dredge going through the Ohio River locks at the town of Leavenworth in Crawford County in 1928.

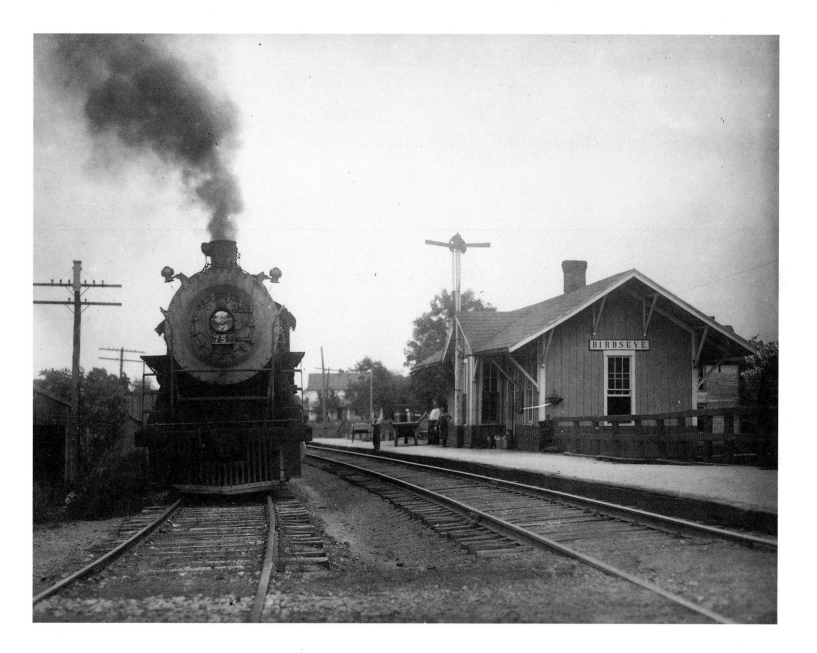

The railroad station at Birdseye, a village in Jefferson Township, Dubois County, in 1933. The station was razed when the railroad ceased passenger service to the village. The Southern Railroad (now the Norfolk and Southern) reached Birdseye in the 1880s, bringing some measure of prosperity to the small community, which was famous for its export of ''Birdseye sorghum.''

A road lined with sycamores near Logansport in 1925. Hohenberger called it Deercreek Road.

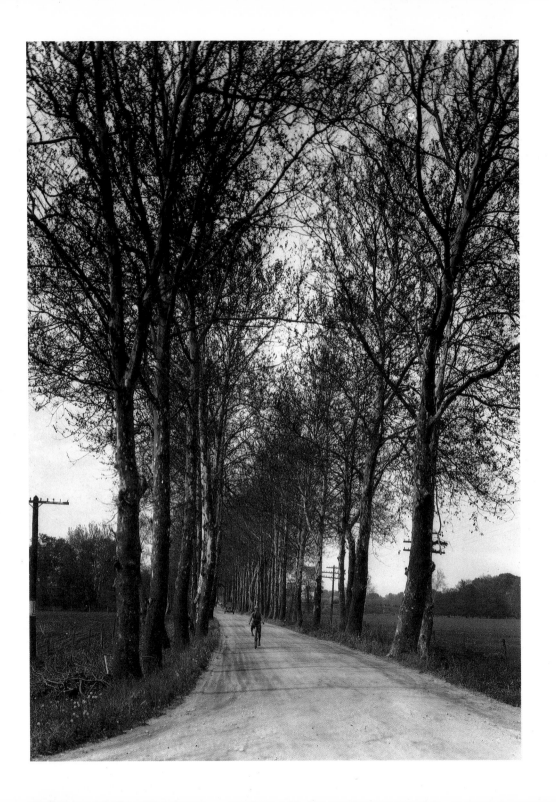

This is a 1925 photo of the Williamson-Wright building in Logansport. The building was constructed in 1838 as a storage facility for commodities to be shipped on the Wabash and Erie Canal. This waterway connected Lake Erie with the Ohio River at Evansville by following the Maumee and Wabash rivers. It reached Evansville in 1853 but was obsolescent before it was finished. It was the longest canal in the United States, extending 468 miles, but was, on the whole, an economic disaster for the state. For Logansport, however, it brought a commercial boom when it reached the city in 1838. The Logansport section of the canal was abandoned in 1875.

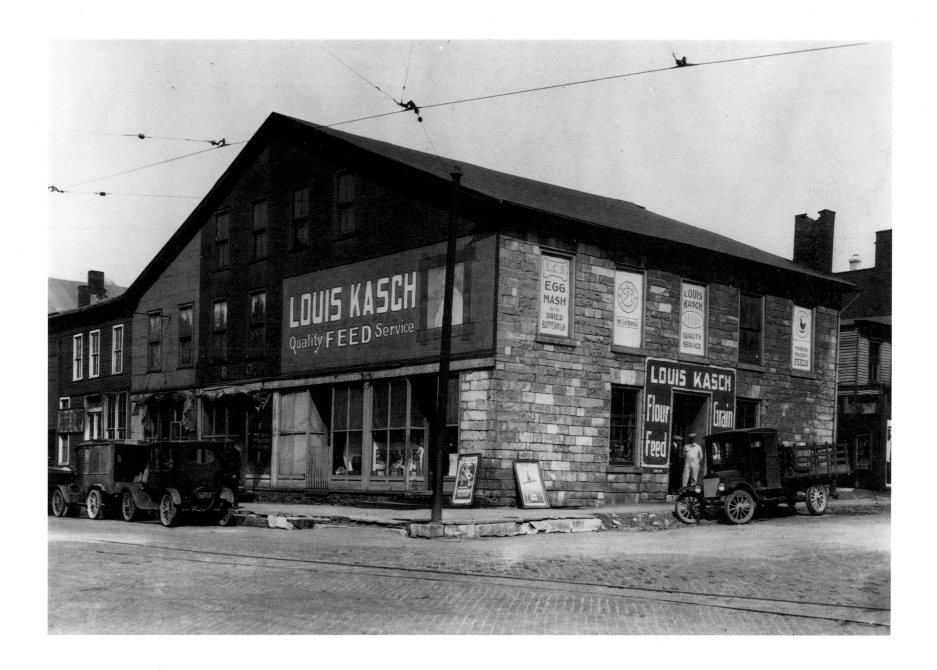

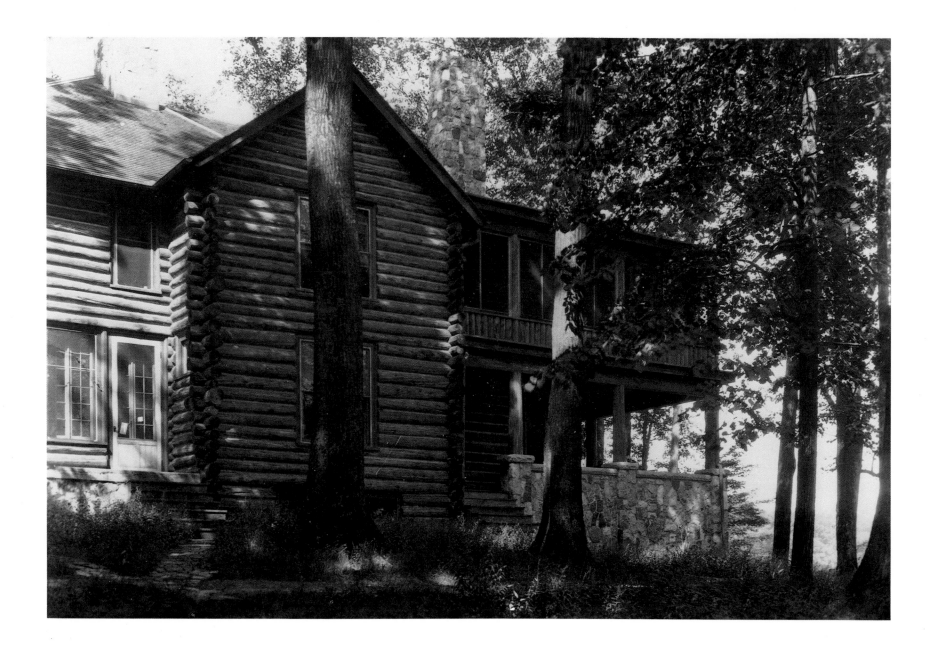

The Gene Stratton-Porter home on the south shore of Sylvan Lake, near Rome City in Noble County, in 1923. The author of *Freckles, A Girl of the Limberlost,* and many other books built this two-story home of Wisconsin white cedar logs and called it "Cabin in Wildflower Woods." She lived there from 1914 to 1919 before establishing her permanent residence in California, where she wrote and formed a company to film her stories.

Hohenberger took a series of photographs for the state park commission in August 1923, before Mrs. Stratton-Porter transferred the Sylvan Lake property to the state. She wrote Hohenberger in September 1923: "I think these pictures for the most part are extremely good, considering the speed with which they were taken and how tired I was at the time." After Mrs. Stratton-Porter's death in an automobile accident in 1924, her daughter Jeannette Porter Meehan bought from Hohenberger all negatives containing photographs of her mother. The print of the Sylvan Lake property and one of the "Limberlost," her first home at Geneva in Adams County, 1895–1913, are the only ones remaining in the Hohenberger collection. The home at Sylvan Lake is today the Gene Stratton-Porter State Historic Site. The home at Geneva is now the Limberlost State Historic Site.

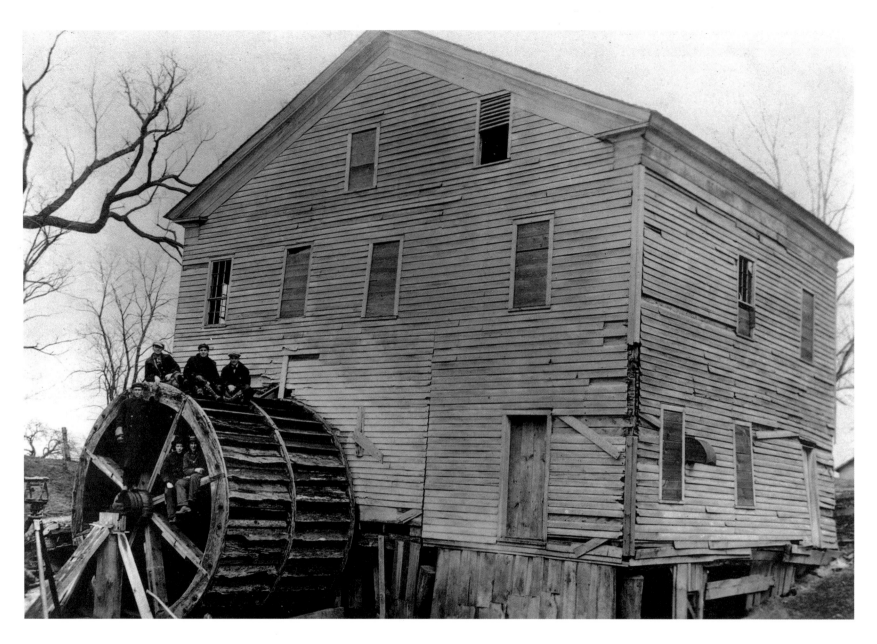

The remains of Bigelow's gristmill, located on Hog Creek in Clinton Township, LaPorte County, about 1925. The mill was erected by Abijah Bigelow in 1837. A village, now gone, called Bigelow's Mills developed in the vicinity of the mill. A succession of owners followed Bigelow. Milling ceased at the site in 1901.

Cecil K. Byrd is a former teacher, Indiana University librarian, retired President of the American University in Cairo, and coauthor of *Indiana University: A Pictorial History*.

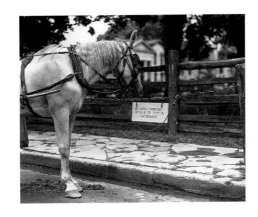

Book and Jacket Designer • Sharon L. Sklar

Copy Editor • Jane Lyle

Production • Harriet Curry

Typeface • Berkeley Book

Typesetter • Weimer Graphics, Inc.

Printer and Binder • Everbest Printing Co., Ltd.